KNITOVATION
STITCH DICTIONARY

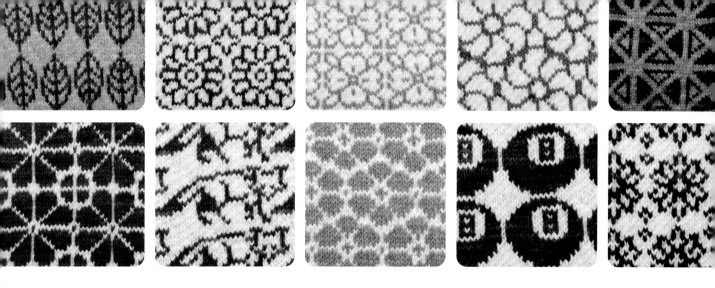

Krause Craft

An imprint of Penguin Random House LLC
penguinrandomhouse.com

ISBN 9780593422700
Ebook ISBN 9780593422717

Printed in China
10 9 8 7 6 5 4

The KnitOvation Team

Kerry Bogert, Project Lead and Editor

Allison Korleski, Editor

Lavon Peters, Proofreader

Susan Moskwa, Tech Editor

Sandi Rosner, Tech Consultant

Dorie Lysaght, Test Knitter

Ashlee Wadeson, Cover and Layout Designer

Sean Rangel, Illustrator (charts)

Walter Colley, Photographer

Marie Spinelli, Photo Assistant

Kim Salley, Stylist

Amy Zubieta, Model

Jennifer Galvez Caton, Model

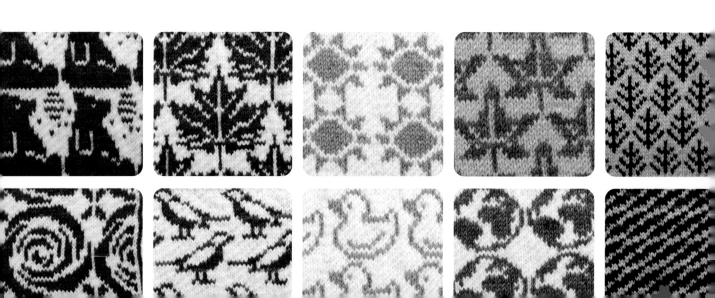

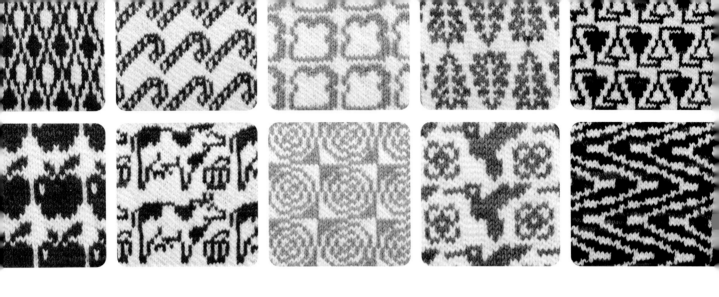

KNITOVATION
STITCH DICTIONARY

150+ modern colorwork
knitting motifs

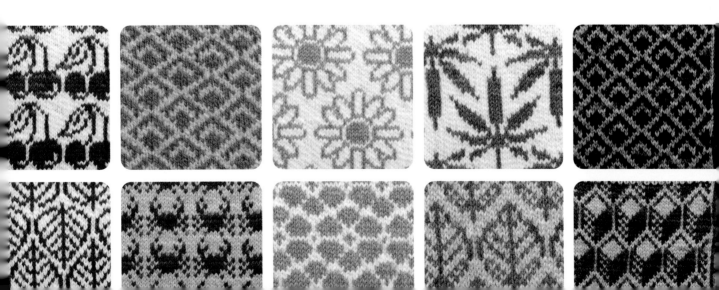

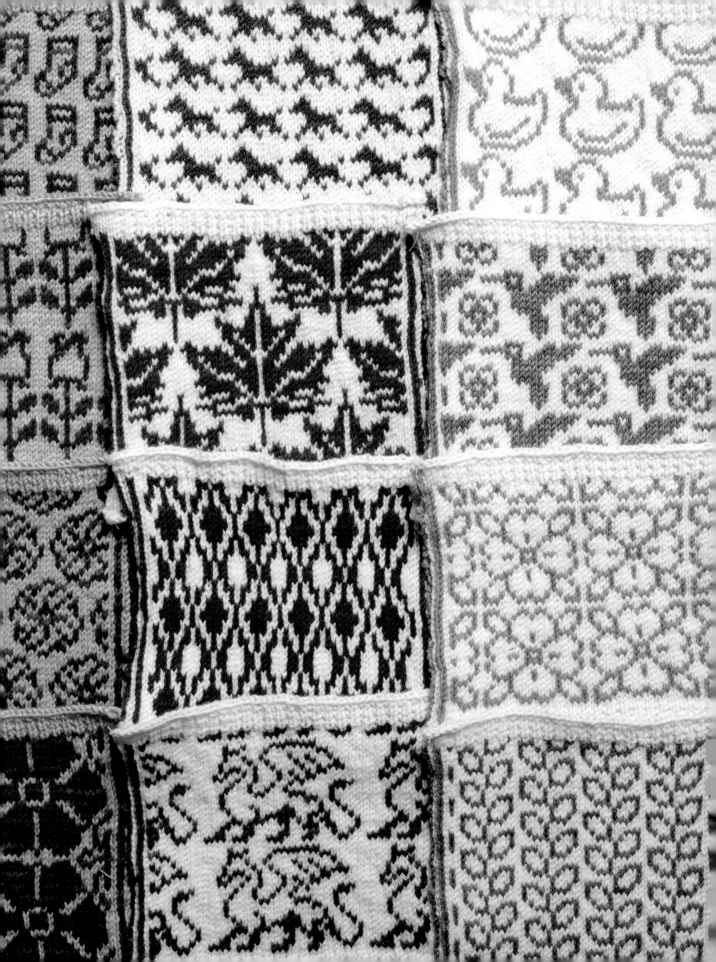

contents

INTRODUCTION

MY FIRST PROJECT

The first knitting project I ever completed was a misshapen, foot-wide strip of dark purple mohair fabric. The knitting had some issues that new knitters are probably familiar with—holes everywhere, wavy edges, and random increases and decreases throughout.

At the time, I was proud of that knitted fabric and was determined to use it. I cut a piece of army-green canvas into a rectangle, stretched the knitted fabric over it, and very unevenly sewed the sides together by hand to make it into a messenger bag. I even added a canvas strap covered in a similarly problematic strip of knitting so that the fuzzy mohair would be on my shoulder. And that's how I carried my books in college. I'm pretty amazed the seams held up under the massive weight of my English literature anthologies and astronomy textbooks for as long as they did!

That project was dreadful and it's long since gone, but I'd been given the yarn by my auntie (a skilled knitter who was very generous with her materials), and I remember it fondly. I made that weird thing over 20 years ago and I've been designing knitting patterns full-time for over 10 years now. My knitting has improved a lot. Maybe more importantly, I still recall feeling the spark of creative possibility in that fluffy purple yarn, and I hope I can pass that spark along to you through the motifs and designs in this book.

FROM *ALTERKNIT* TO *KNITOVATION*

You may have this book in your hands because of my last book, *AlterKnit Stitch Dictionary*. This book is a companion volume and if you loved *AlterKnit*, I really think you'll love this one as well. At the same time, I created it to stand on its own with more than 150 new motifs, a chapter contemplating yarn choices, and three original projects to help illustrate design concepts and provide you with a jumping-off point for using the motifs in any project you choose.

As in *AlterKnit*, all the motifs in this book were designed and named by my husband Sean, an artist with a clever imagination; I couldn't have made the book without his partnership and support. We had a lot of fun together making this book and I wish you the same kind of silly joy as you exercise your own creativity.

This book is for knitters who enjoy stretching themselves a bit, folks who want a little whimsy, and those who can't wait to cast on the next new project. It's meant to inspire you to add colorful playfulness to your knitting—whatever you like to knit.

Flip through it casually and put sticky notes on motifs that grab your attention. Ask your non-knitting family members which motifs they like. I've arranged the book in a way that felt intuitive, fun, and interesting so that it would always be surprising! I hope that while you're hunting for that perfect floral, you might instead stumble on a striking geometric motif, or something that gives you a completely different idea.

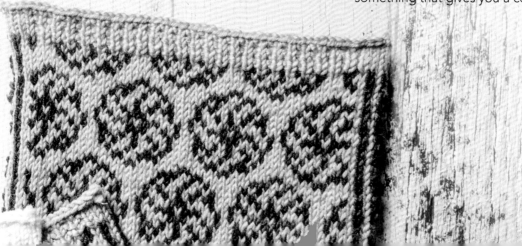

Don't forget to look over the other sections of the book. You'll find useful information on designing with colorwork, how yarn choice impacts the look of colorwork fabric, and how to use duplicate stitch to embellish your work.

There are very many ways of knitting, a wide variety of materials to choose from, and an infinite number of ridiculous and beautiful things that a person can knit. I hope that you will let your creative impulses guide you and that you'll keep trying even if/when the first things you do don't come out exactly as you'd planned. Each experiment is a point on your journey as you learn more about this delightful craft and your own personal expression.

HOW TO USE THIS BOOK

The motifs in this book are intended to be a jumping-off point for your own creativity, so I hope that you use them in your original designs, or as an element of a new knitting pattern! Think of this as any other stitch dictionary—an addition to your knitting toolkit. You can use the motifs without credit to me or the book, but I do love learning about it when folks have found the motifs inspirational. Tag me on Instagram @AndreaRangelKnits or send me an email at Andrea@AndreaRangel.com to share your creations.

My ambition is for this book to be a collaboration with every knitter who will open its pages. Here's to your knitting and creative expression!

Andrea Rangel

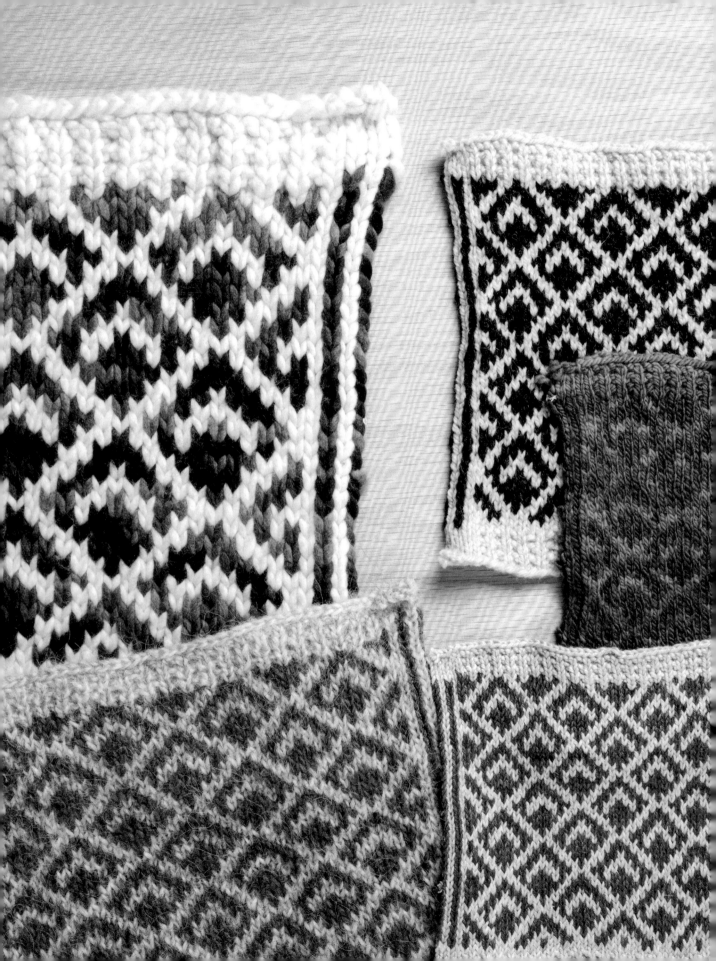

KNITTING IN COLOR

Successful stranded colorwork is about more than choosing colors. It's about choosing yarn based on fiber, weight, and yarn construction. In this chapter, explore the impacts of different fibers and yarns on colorwork projects.

CHOOSING YARN FOR COLORWORK

You can knit stranded colorwork in any yarn. However, characteristics of the yarn you choose will make a huge difference in how your finished fabric looks, feels, and behaves. Every yarn has a variety of elements that make it unique. Fiber content, how the yarn is spun, the number of plies in a yarn, how tightly those plies are twisted, and the thickness of each strand all play a role. These elements interact, giving each yarn varying degrees of softness, elasticity, and texture.

To capture some of the diversity in different yarns, this chapter includes a gallery of samples all knit in the same motif. This is by no means an exhaustive list of all types of yarn, but is intended to be a visual resource to show you how much yarn choice matters in achieving your desired finished result.

First, to better understand what you see in the gallery, let's discuss some key characteristics of yarn. These are the vital details to consider when thinking about colorwork and choosing a yarn for your project.

FIBER CONTENT

When choosing a yarn, first and foremost consider the fiber from which it is made. For stranded colorwork, wool will always be my go-to choice—though far from the only one. Wool is elastic, meaning the fibers easily stretch, then return to their original size. This helps you maintain an even tension while you knit, giving you a smooth surface and even fabric. Stranded colorwork is often used for hats, socks, and other items that benefit from wool's ability to stretch to fit, without ever losing its shape.

Wool ranges from next-to-the-skin soft to coarse and prickly. While you want a sweater that's comfortable, a somewhat "sticky" or "toothy" yarn is the traditional choice for stranded colorwork, because the fibers hold on to one another. If you're a beginner and you worry about keeping your tension even, you'll likely have more success starting with wool. And if your wool is relatively grippy, your stitches are more likely to keep the size and shape that they had the moment you knit them.

Inelastic fibers such as silk or cotton have beautiful drape but are also more likely to have tension issues. Because they are more slippery and less elastic than wool, they are more likely to respond to random pulls and tugs. Stitches can become distorted, either tighter or looser than their neighboring stitches, and the resulting fabric might be uneven.

"Sticky" or "hairy" fibers have an added benefit. More often than not, when you drop a stitch with textured yarn, the stitch will sit there patiently, just waiting for you to notice and fix it. It's nothing to stress about. Now, think of dropping a stitch on an intricate lace project in a shiny silk. You know it will unravel completely at the slightest breeze before you've realized what's happening because you shifted slightly to the left in your chair. This tendency to stay put or run away has a huge impact on how even your stitches, and thus your fabric, will be. So, keep it in mind.

TIP: Surface Texture
Speaking of texture, nubby yarns and ones with hairy surfaces will create a more mellow look. If you want popping, clear stitches, you'll want a smoother yarn.

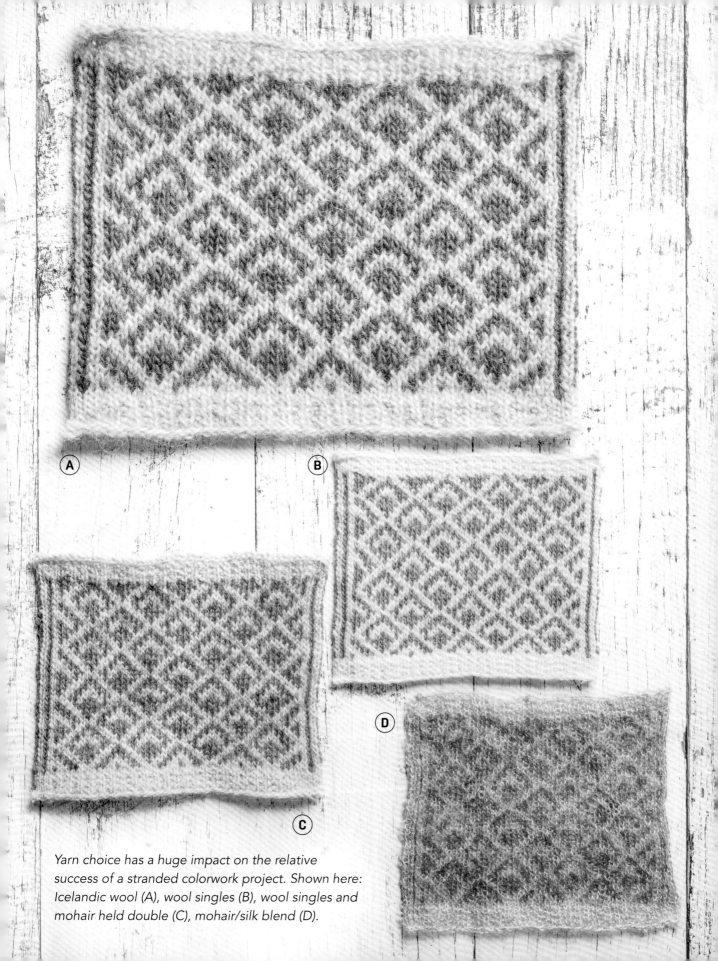

Yarn choice has a huge impact on the relative success of a stranded colorwork project. Shown here: Icelandic wool (A), wool singles (B), wool singles and mohair held double (C), mohair/silk blend (D).

FIBER PREPARATION

Even if we were just evaluating wool and no other fibers, how it's prepared for spinning will make a huge difference in the finished yarn. The main two preparation methods to know are worsted-spun and woolen-spun.

Worsted-Spun Yarns

When fiber is prepared for worsted spinning, it's combed carefully so that all the strands are going in the same direction. Very short and very long fibers are removed so that the remaining fibers are all about the same length.

To imagine this, picture a handful of spaghetti that you're about to toss in the pot. Just like the noodles, strands of worsted-spun fiber are densely packed together and uniform in length. When fibers prepared this way are spun together, they create a dense, strong, smooth strand of yarn, even if the base fiber is somewhat coarse.

Woolen-Spun Yarns

Alternatively, to prepare fiber for woolen spinning, the fibers are carded, instead of combed. Long, medium, and short fibers are jumbled together into a fluffy, airy mass.

This time, to picture it, think of cotton candy. When carded fiber is spun, it creates a yarn that's loftier and lumpier, with pockets of air. The surface of a woolen-spun strand has more cavities and texture than you would get from worsted spinning. Fabric made from this kind of yarn is very lightweight and warm.

Telling the Difference

There are many yarns in between these two extremes, but it's good to know the broad categories. Most yarns don't list the spinning preparation method on the label, so if you're not sure, one easy test is to try to break the strand with your hands. If it pulls apart easily, it's likely woolen-spun. If it hurts your hands and won't break at all, it's probably worsted-spun.

Generally speaking—and to easily compare the two—most sock yarns are worsted-spun, and fuzzy Shetland-style yarns are woolen-spun.

YARN ELASTICITY AND PLY

Another characteristic that impacts stitch definition and how well stitches stay in place is how bouncy the yarn is and how much it tends to return to its original length after being stretched—its elasticity.

Both fiber content and how it's spun will affect a yarn's elasticity. As mentioned, wool is more elastic than silk, linen, cotton, or alpaca. Within the category of wool, breeds like Cormo and Bluefaced Leicester (BFL) are more elastic than Merino.

Yarn can be made more elastic by spinning it tightly, adding extra twist that acts like a spring. Twisting multiple strands, or plies, together also increases the overall bounce of a yarn. Yarn made from slippery, inelastic fibers like cotton, silk, and alpaca can get some bounce from being tightly spun and plied. Still, the smoothness and lack of elasticity in plant fibers, silk, and alpaca mean that all of them can be tricky for colorwork. Even after the knitting is done and blocked, those stitches can shift and make for a fabric that looks a little sloppier than fabric made from wool.

YARN AND FIBER WEIGHT

When measuring weight, there are two things to consider in the knitting sense. How thick or thin the strand of yarn is determines the yarn weight, and the skein's weight in ounces (grams) can indicate the fiber weight.

Yarn Weight

It's important to consider how thick your fabric will be and to think about whether that makes it a good fit for your purpose. For example, using a super bulky yarn for colorwork is a fun idea, but it's also a pretty niche thing to do because it will probably be a half-inch (more than 1 cm) thick and have limited applications.

Yarn weights in order from thinnest to thickest: lace, fingering, sport, DK, worsted, aran, bulky, and super bulky.

Fiber Weight

How much a finished sweater weighs on the scale matters, too. If you make an entire colorwork pullover in cotton worsted-weight yarn, it's going to be heavier than a wool worsted-weight sweater. The weight of the sweater is going to stretch as it hangs on the body. Because cotton lacks elasticity, there's nothing to bring it back to the intended length. You're likely to end up with a much longer and skinnier garment than you had in mind.

BRINGING IT ALL TOGETHER

Worsted-spun yarns create a fabric that has clearer stitch definition, so if your goal is colorwork that really pops in a visually crisp way, a good compromise is to use a plied yarn that offers elasticity while still having a smooth strand.

I love Neighborhood Fiber Co. Organic Studio Sock—the yarn I used for the Motifs & Swatches chapter (p. 26) of this book—for this reason. While the Merino is extremely soft and smooth, the yarn is also durable and has elasticity. The yarn is made of many tightly spun plies, which provides its durability and elasticity for socks and results in crisper stitches than you would see in a looser-spun or fewer-plied yarn.

No matter what yarns you choose, your own experience as a knitter can have significant impact on tension in stranded colorwork projects. If you are new to managing two yarns at the same time, don't judge yourself if your fabric isn't as perfect as you'd like it to be. See Colorwork Knitting Tips (p. 24) for more information.

A NOTE ON KNITTING IN THE ROUND & STEEKS

I prefer knitting colorwork in the round rather than back and forth in rows because when you work in the round, the public side of the work is always facing you. It's easy to see what happened before in the pattern and what should happen next. Plus, I find it pretty finicky to purl in colorwork.

To always have the public side facing, to avoid purling stranded colorwork, and to still have open cardigan fronts, armholes, and necklines, many folks knit the whole project in the round and then cut their knitting open. This invigorating method is referred to as steeking.

Extra stitches are added at the point where the cut will happen in order to create a little buffer, and the panel of extra stitches added is called a steek. The steek panel is usually reinforced in some way before cutting, either by needle felting, crocheting, or sewing using a sewing machine.

If you want to steek, yarn choice is trickier. If using slippery yarns, such as silk or plant-based fibers, you need to reinforce more seriously or avoid steeking altogether. Sticky yarns, such as Shetland wool, can be steeked without worry of stitches unraveling when reinforced and cut.

YARN GALLERY

The swatches shared in this section represent a range of yarns in fibers and blends readily available today. For each, I share a bit about the yarn and what projects I would use—or not use—them for when knitting colorwork. Then, we'll look at how dye effects can impact the look of colorwork.

Note: All yarns are worsted-spun unless otherwise indicated.

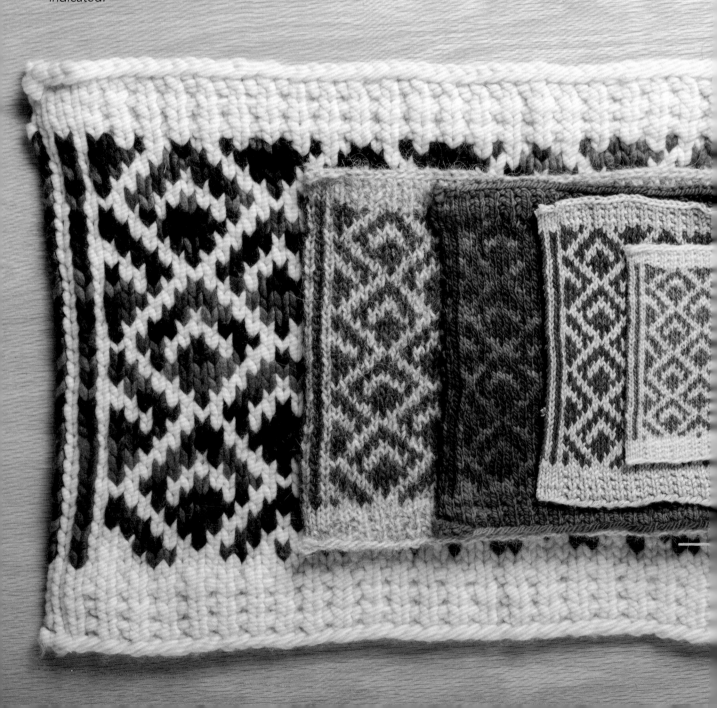

merino wool

Neighborhood Fiber Co. Organic Studio Sock
Fiber: *100% superwash Merino wool*
Weight: *Fingering*

I knit the motif swatches in this book out of this yarn, so you know I'm a fan. There are so many things that I love about it. It's tightly twisted with four plies that each have two plies in them. That makes a really round, balanced yarn that has wonderful elasticity. The construction also makes a durable yarn, and the Merino means it's super soft, so you can knit anything with it. Neighborhood Fiber Co. uses an environmentally friendly process to make their organic Merino superwash, and the enormous color range is incredible. This yarn is also 100% certified organic by GOTS (Global Organic Textile Standard).

While the visual samples in the Yarn Gallery appear to be roughly the same size above their descriptions, they're actually quite different. As you can see here, the gauge varies greatly.

woolen-spun shetland wool

Jamieson's Shetland Spindrift
Fiber: *100% Shetland wool*
Weight: *Fingering*

Shetland refers to a breed of sheep from the Shetland Islands, an archipelago in the northernmost region of the United Kingdom. This two-ply, woolen-spun yarn has a grippy texture and is very lightweight. It's a classic colorwork yarn that's used in traditional Shetland and Fair Isle knitting, and it's a wonderful choice for folks new to colorwork. It's not particularly soft, but it's perfect for cardigans and hats that will keep the wind out. The look is relatively rustic. Another bonus for this yarn, and most other Shetland yarns, is that they tend to be sold in small, affordable skeins so you can choose a ton of colors for your project. Traditional Shetland colorwork knitting often has small colorwork motifs and many colors in one project. Because this yarn is woolen-spun, it's not particularly suited for items that get a lot of wear, such as socks.

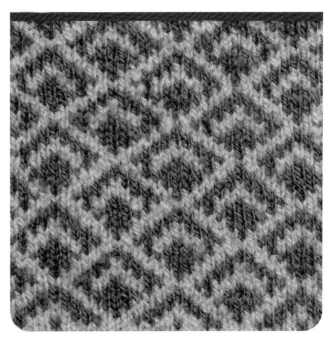

ICELANDIC WOOL

Ístex Léttlopi
Fiber: *100% Icelandic wool*
Weight: *Heavy worsted*

Icelandic sheep are a heritage breed from Iceland, with wool that suits the environment there perfectly. Léttlopi yarn is durable, light, and extremely warm. Two lightly spun plies are loosely twisted together for a lofty airiness, and fluffy hairs sit on the surface of the fabric, making it look a little mellower and less crisp than other yarns. It can be knit at a loose gauge and the stitches relax into each other really well. Softness is subjective, but this is one that I personally wear as outerwear, rather than close to my neck, because I find it a bit prickly. This is a great choice for beginners because it's toothy and can be used to make a very quick hat or sweater.

RAMBOUILLET WOOL

Ritual Dyes Maven
Fiber: *100% Rambouillet wool*
Weight: *Fingering*

This yarn has a lot of texture, as well as being very soft and bouncy. Rambouillet wool is slightly less soft than Merino but more elastic. It makes a fabric that isn't very crisp, but rather has a more rustic look to it, almost like an antique tapestry. It's also wonderfully spongy when you squish it. If your goal is a gentle, natural look, this is a great option.

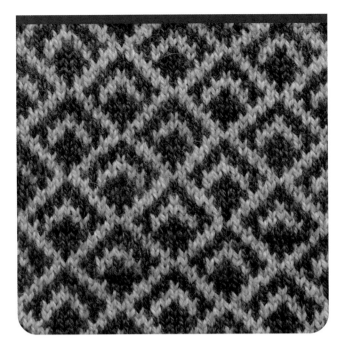

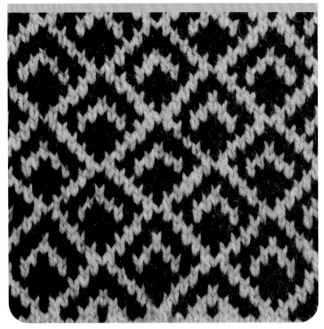

BLUEFACED LEICESTER WOOL

Emily C Gillies BFL Fingering
Fiber: *100% BFL wool*
Weight: *Fingering*

BFL is a soft wool with long lustrous fibers that give it a sweet shine. It's generally relatively sticky and bouncy, so it's lovely for beginners knitting colorwork. If you want to nerd out about breed-specific yarns, you need to give BFL a try. The surface of the fabric is halfway between the smoothness of sock yarn and the rustic vibe of Shetland yarn. This particular yarn is a two-ply that's not particularly tightly twisted, so it's got a bit of texture to it while still being quite durable thanks to the tough BFL fibers.

WOOLEN-SPUN CORMO WOOL

Harrisville Designs Daylights and Nightshades
Fibers: *80% Cormo wool, 20% other wool*
Weight: *DK*

Cormo is one of my favorite wool breeds because it's extremely soft, spongy, and bouncy. A three-ply, woolen-spun preparation makes it super light and lofty with a wonderfully dry, raspy surface. It's great for colorwork. Cormo is a good choice for any garment or accessory except socks. Woolen-spun yarn isn't ideal for socks because it lacks the durability needed to withstand the friction that wearing socks causes.

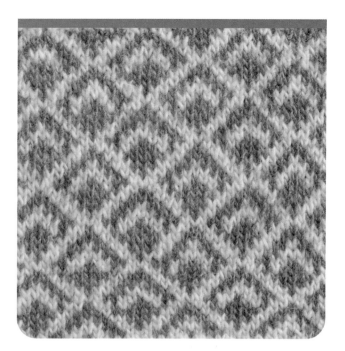

WOOL SINGLES

Julie Asselin Nurtured Fine
Fiber: *100% wool (Rambouillet, Targhee, and Merino)*
Weight: *Lace*

When yarns have just one ply that's twisted to give it strength, they are called singles. This particular yarn has a toothy feel with bit of a nubbly texture. The yellow has flecks of other colors, which gives it a tweed look. The stitch definition is clear, but, as is common with singles yarns, it's got a softness to the surface, too. The yarn isn't super smooth, so the stitches hold onto each other pretty well. It's definitely crisper than the one held with mohair/silk (p. 21), but it's still got a little softness to the look, which happens with singles yarns.

SUPER BULKY WOOL SINGLES

Neighborhood Fiber Co. Rustic Bulky
Fiber: *100% Merino wool*
Weight: *Super bulky*

I just had to include a super bulky yarn like this to show how adorable those enormous stitches can be! But know this: The fabric is very thick, making it impractical for many applications. I suggest a hat or slippers for this type of fabric. That said, don't let my review stop you. If you think it's just what you want for a warm winter sweater, go for it!

ALPACA

GN'R Alpaca Farm 100% Alpaca
Fiber: *100% alpaca*
Weight: *DK*

Alpaca is a fiber that's been used for colorwork and warm garments by many, and it has some very special properties that make it unique. Alpaca varies in its degrees of softness. GN'R is soft and has a dramatic halo, with wispy hairs that sit on the surface of the fabric. It's lustrous with a very dramatic drape that's quite beautiful. However, it's not an elastic fiber and it's denser and heavier than wool. It will definitely grow vertically with wear. To mitigate that tendency, I suggest knitting alpaca at a dense gauge and reserving its use to accessories. Any adult-sized sweaters would benefit from reinforcements such as seams at the sides of the body, shoulders, and armholes.

COTTON/NYLON BLEND

Trailhead Yarns Appalachian Trail
Fibers: *65% cotton, 35% nylon*
Weight: *Fingering*

This is a cool, crisp yarn that knits up with relatively neat stitches. Nylon adds elasticity and reduces weight so it can work better for colorwork than 100% cotton might. Some folks find that cotton and other plant fibers are a little hard on the hands while knitting because they don't stretch much. The nylon content here helps with that, and also makes it extremely durable. Many sock yarns contain nylon for this reason.

SILK/LINEN BLEND

SweetGeorgia Yarns Flaxen Silk DK
Fibers: *65% silk, 35% linen*
Weight: *DK*

I must admit that this yarn surprised me. I expected my stitches to be sloppy, given how inelastic both silk and linen are and how smooth silk is; it actually looks beautifully crisp with a slight bit of shine. Even so, I'd be hesitant to make an adult garment out of this as I'd expect it to stretch out of shape. I think it would be perfect for a drapey shawl or cowl, though. Linen is known for wearing beautifully and getting softer over time, so this could be a go-to for mild weather projects.

MOHAIR/SILK BLEND

Julie Asselin Anatolia
Fibers: *60% kid mohair, 40% silk*
Weight: *Lace*

Mohair/silk lace-weight yarn is a pretty common yarn base that many companies make, and that's because it's gorgeous. These fibers are spun together because they have attributes that balance each other beautifully. Brushed mohair can add a fluffy halo to the surface of your fabric and silk, is strong and shimmery—almost reflective. It adds drape and fluidity, and it moderates the fluffy mohair with a bit of elegance. Mohair/silk blends have a cozy, gentle, soft feel that mellows the stitches and gives the fabric a well-loved look.

Working colorwork in mohair/silk blend alone creates a fabric that's gauzy and almost transparent, with colors that blend into each other. This fabric is very distinctive and beautiful, in my opinion.

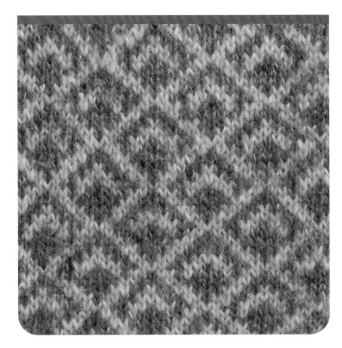

MOHAIR/SILK HELD WITH WOOL SINGLES

Julie Asselin Anatolia and Nurtured Fine

Knitters who love that halo and shine of mohair/silk but prefer a more traditional feel to the fabric can choose to hold it with a strand of fingering weight wool yarn. The wool adds elasticity and solidity to the fabric. It's still airy, fluffy, and shiny, but it's also more opaque and the colors look a little crisper. The fabric has a lot more weight and drape to it than the airy mohair/silk only option. It's automatically fancier than the wool alone and more practical than the mohair/silk alone.

One other note about working with mohair: It's warmer than wool. So, a mohair/silk/wool garment will be exceptionally cozy.

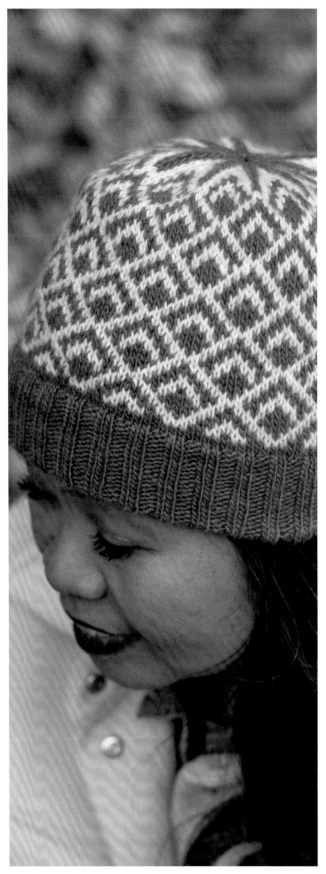

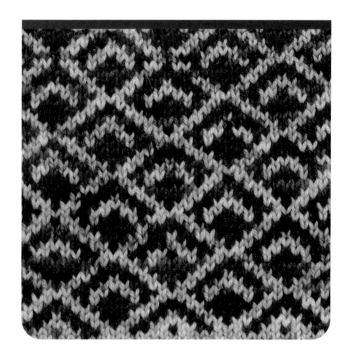

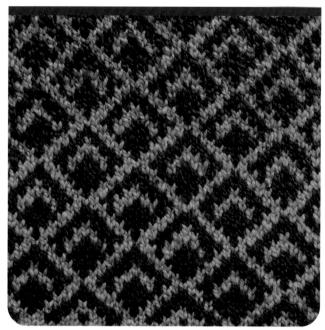

SEMI-SOLID & SPECKLED COLOR

Neighborhood Fiber Co. Studio Sock and Sew Happy Jane Happy Fingering
Fibers: *Studio Sock: 100% superwash Merino wool; Sew Happy Jane: 75% Merino wool, 25% nylon*
Weight: *Fingering*

Colorwork with sock yarns can be really fun because the colors are so saturated and the smooth yarn makes very crisp stitches. Adding speckles and semi-solids or variegated yarns makes a more painterly look. One thing that makes this combination interesting is that some of the speckles in the pale gray yarn are a similar color to the dark purple, so the resulting pattern isn't perfectly clear. I love the dark yellow bits and I think they set off the purple beautifully. If you're looking to combine yarns that have more than one color, it's probably best to use yarns that are mostly very different—one very dark and one very light. Of course, with speckles, you get those dark pops in my pale gray yarn, but as long as that's intended and you like how it looks, go for it.

LONG-REPEAT VARIEGATED COLOR WITH A SOLID COLOR

Spincycle Yarns Dyed in the Wool and Nocturne
Fibers: *Dyed in the Wool: 100% superwash American wool; Nocturne: 100% Merino wool*
Weight: *Sport*

These yarns are simply a delight because each skein is unique and the colors are just fascinating! I chose one color that's relatively light (with some pops of medium color in there) and one that's relatively dark throughout to get a nice contrast. It's fun to see the colors change and meld as you knit. This is obviously really distinctive, but long-repeat variegated yarns like this might be exactly the creative look you'd like to achieve. If you choose colorways that have both light and dark colors in them, you're going to get a surface pattern that's not super clear, but it could still be beautiful. I chose this yarn combination for the Nautilus Fingerless Mitts that you'll find in the pattern section (p. 120).

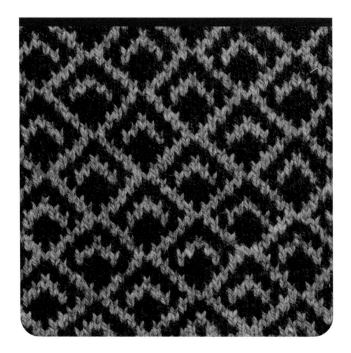

HEATHERED COLOR

Hudson + West Co. Weld
Fibers: *70% Merino wool, 30% Corriedale wool*
Weight: *Fingering*

This is a well-balanced yarn in that it's soft but toothy. It has a heathered look so the colors have depth and character. It's considered semi-worsted-spun, which means it's smooth enough that the stitches in colorwork stand out nicely, but not so slippery that it's difficult to keep consistent tension.

TONAL COLOR

The Farmer's Daughter Pishkun
Fibers: *100% Montana and Wyoming Rambouillet wool*
Weight: *Heavy DK/light worsted*

Rambouillet wool is slightly less soft than Merino but more elastic. Pishkun is a velvety soft, textured yarn. It's lovey to knit with because of how spongy and bouncy it feels. Its soft and elastic qualities make it a great medium-weight sweater yarn. I used this yarn for the Midnight Garden Pullover (p. 128). Colorwork in this yarn is painterly due to the nubbly texture and tonal colors. Tonal yarns feature light and dark shades of the same color. You see it most effectively here in the golden-colored yarn.

COLORWORK KNITTING TIPS

Want to improve the look of your colorwork so that the fabric is smooth and even and the stitch pattern looks beautiful? Here are my top five tips to help with that.

Spread out the stitches. As you work across a row or round, spread out the stitches just worked, especially when you're about to switch colors after a long section of one color. One of the most common colorwork problems is having floats that are too short. Spreading stitches out helps keep those strands at the back of the work just the right length.

Be consistent in how you hold your yarn. You can hold one strand in either hand or both strands in one hand; just be sure that whatever you do, you keep their position the same throughout your work. So if you're holding the dark color in your left hand and the light color in your right, keep it that way for the whole project. If both strands are in one hand, keep them in the same position so that one is always on top and the other is always on bottom. The position of the yarn impacts how much yarn is drawn into each stitch and if you switch it up, it can make your work look subtly sloppy. If you want to learn more about this, the term to look up is "yarn dominance."

Manipulate unruly stitches with the tip of a knitting needle. If you notice some of your stitches looking uneven or a different size than their neighbors, just use the tip of your needle to give the smaller leg a little tug. You can move extra yarn from a tiny stitch into a bigger stitch next door. This is especially helpful if you're using a slippery yarn that's shiny and wonderful, but doesn't knit up as neatly as you would like.

Keep your yarn balls separate. Tangling can get worse very quickly. I always keep one ball on the left side of my body and one on the right, and as soon as they start to be a bit tangled, I unwind them and put them back where they should be.

For maximum impact, work colorwork with one very light color and one very dark. A high contrast between your colors keeps the pattern from looking muddy. To see the contrast, take a black and white photo of the two colors side by side. Grayscale makes it easy to see the different value of the colors.

And here's one last bonus tip, because I can't help but talk about blocking! **Block your work** before you decide whether you like it and whether you've achieved gauge. Just a simple soak in the sink and laying flat to dry always make a huge difference!

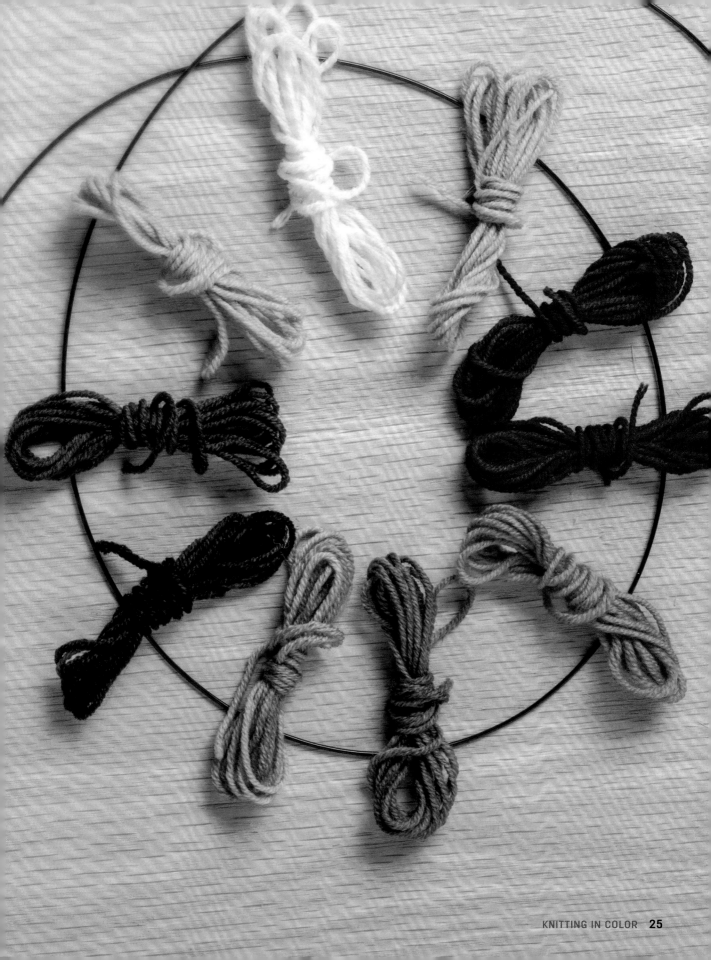

CHAPTER 2

MOTIFS & SWATCHES

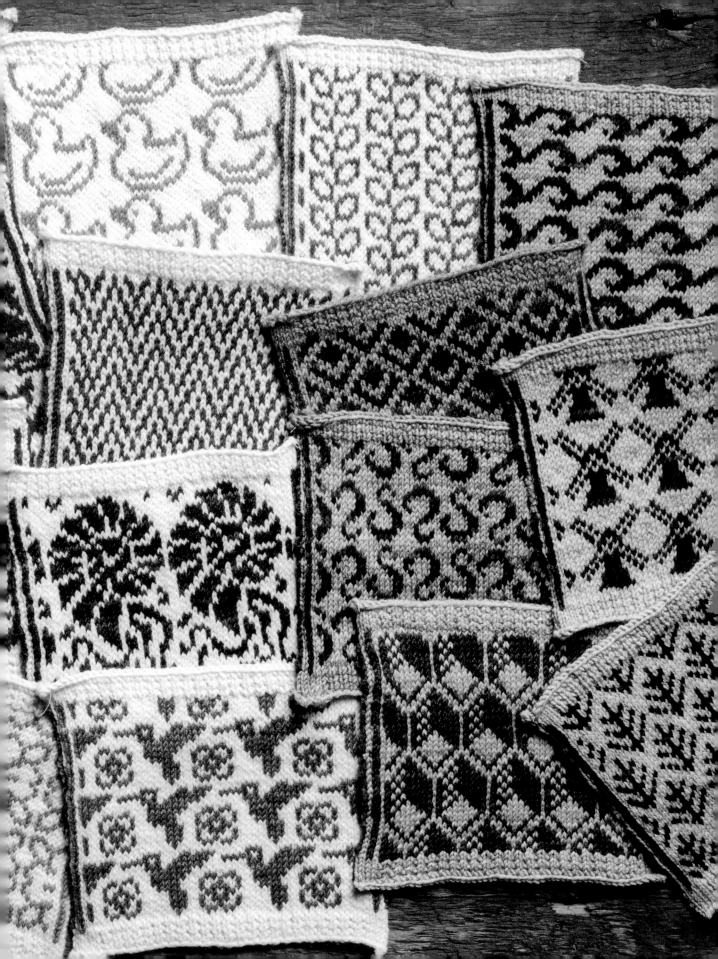

Big leaf Maple

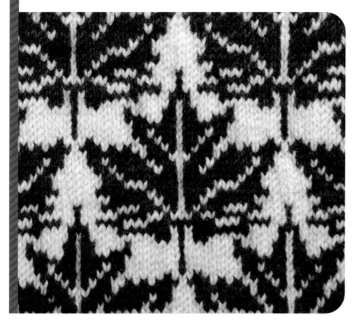

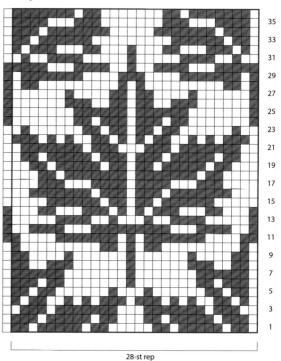

multiple of 28+1

35
33
31
29
27
25
23
21
19
17
15
13
11
9
7
5
3
1

28-st rep

OH canada

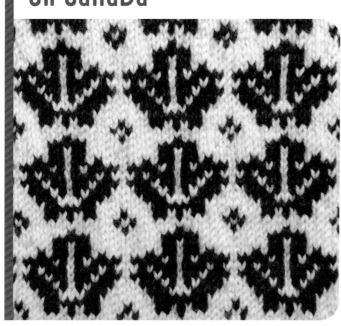

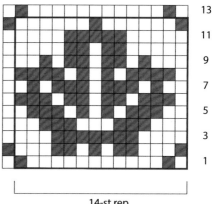

multiple of 14+1

13
11
9
7
5
3
1

14-st rep

multiple of 16+1

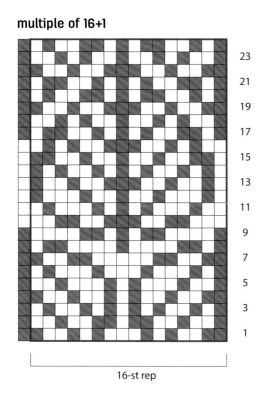

23
21
19
17
15
13
11
9
7
5
3
1

16-st rep

ASPEN

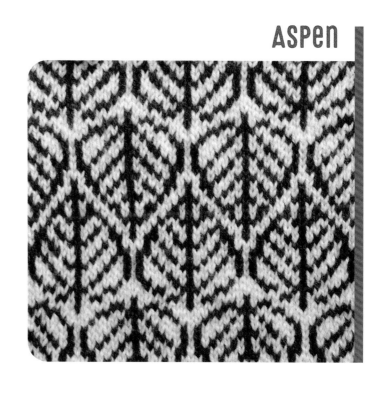

multiple of 21+1

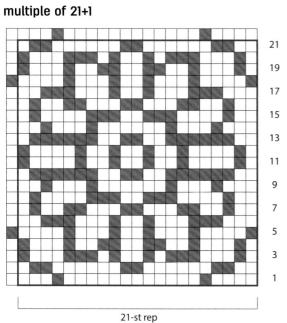

21
19
17
15
13
11
9
7
5
3
1

21-st rep

DAISY

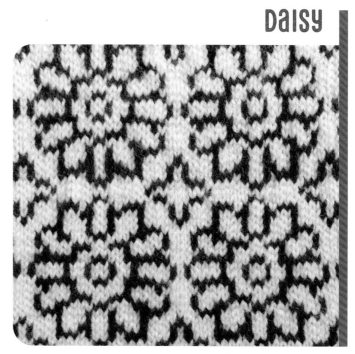

DENDROBIUM

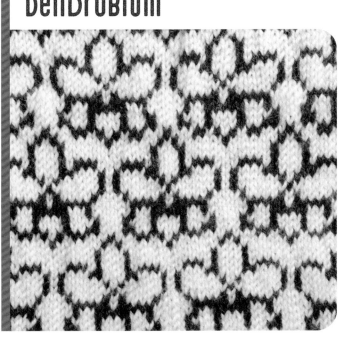

multiple of 16+1

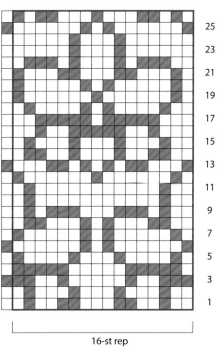

16-st rep

WATER LILY

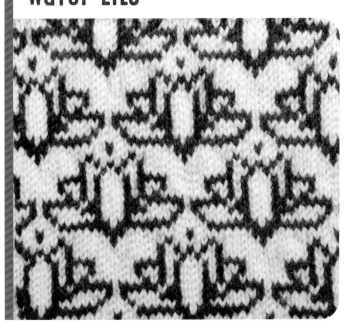

multiple of 20+1

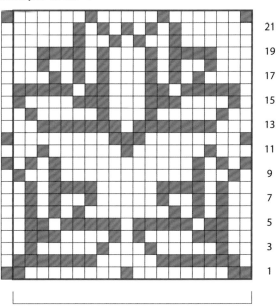

20-st rep

multiple of 20+1

21
19
17
15
13
11
9
7
5
3
1

20-st rep

WILLOWHERB

multiple of 8+1

15
13
11
9
7
5
3
1

8-st rep

ARTIFACT

GranD Rose

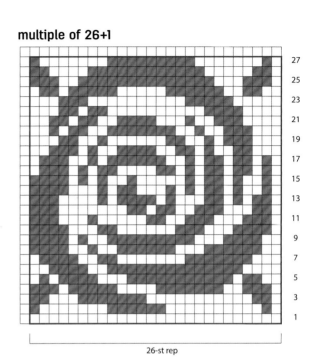

multiple of 26+1

27
25
23
21
19
17
15
13
11
9
7
5
3
1

26-st rep

MOSaIC

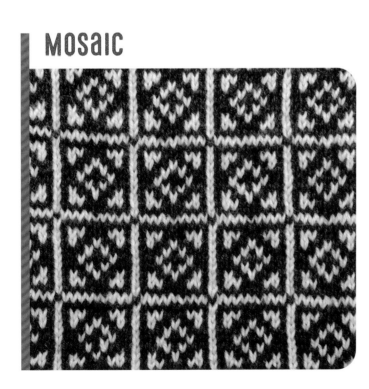

multiple of 10+1

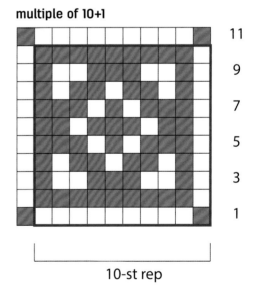

11
9
7
5
3
1

10-st rep

multiple of 18

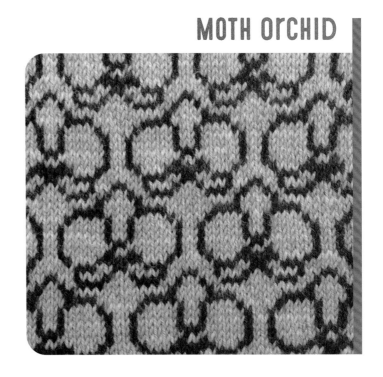

21
19
17
15
13
11
9
7
5
3
1

18-st rep

MOTH OrCHID

multiple of 10+1

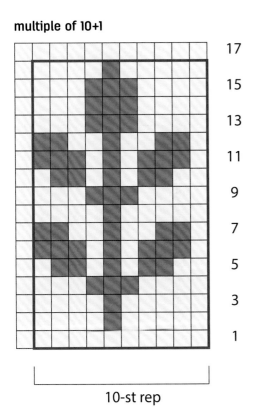

17
15
13
11
9
7
5
3
1

10-st rep

LeaFLeTS

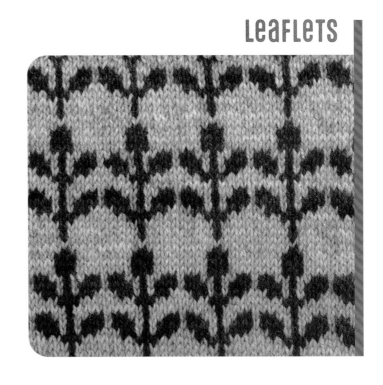

ROSE

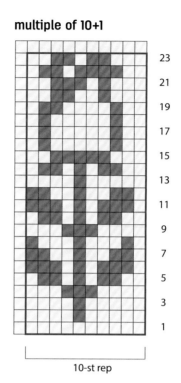

multiple of 10+1

23
21
19
17
15
13
11
9
7
5
3
1

10-st rep

MALUS

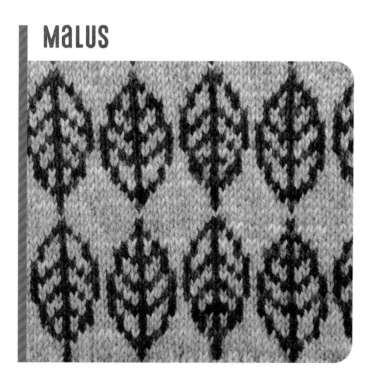

multiple of 20+1

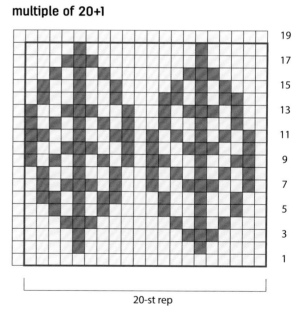

19
17
15
13
11
9
7
5
3
1

20-st rep

multiple of 24+1

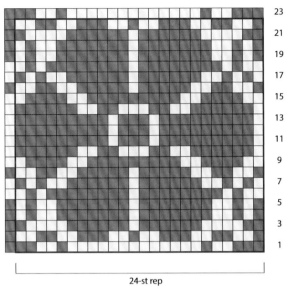

24-st rep

multiple of 11

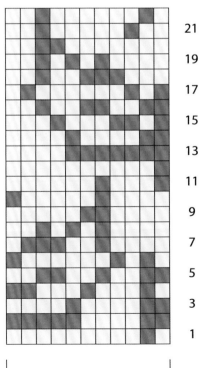

11-st rep

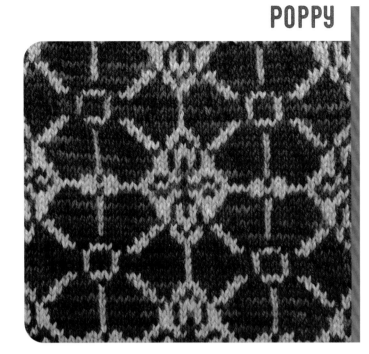

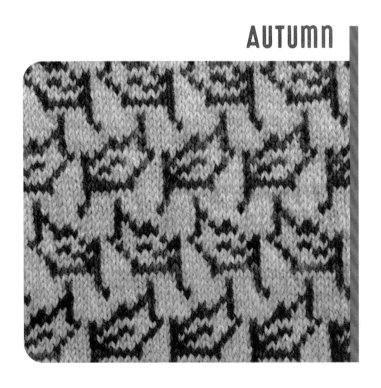

Hazelnut

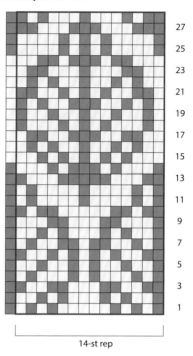

multiple of 14+1

27
25
23
21
19
17
15
13
11
9
7
5
3
1

14-st rep

Cotyledons

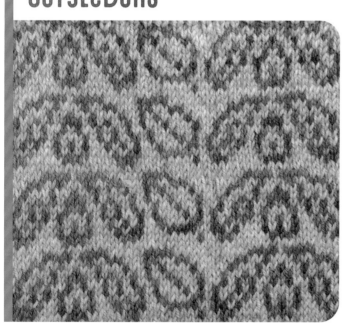

multiple of 28+1

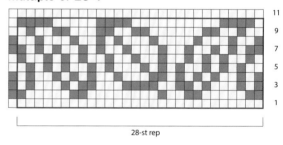

11
9
7
5
3
1

28-st rep

multiple of 18+1

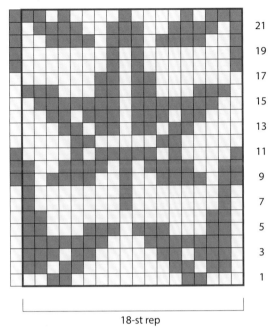

21

19

17

15

13

11

9

7

5

3

1

18-st rep

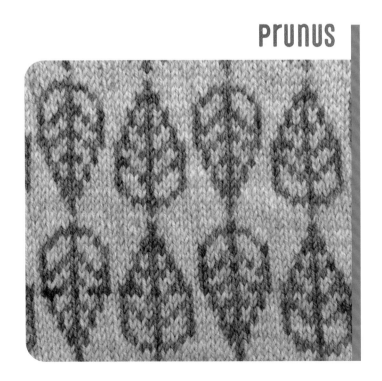

multiple of 20+1

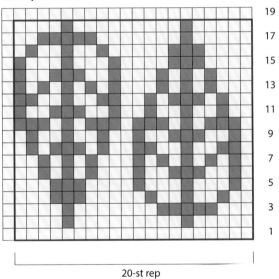

19

17

15

13

11

9

7

5

3

1

20-st rep

BIRCH

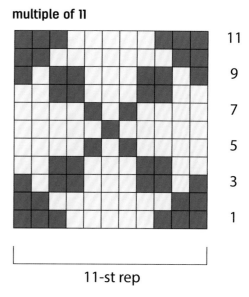

14-st rep

CRYSTALS IN LIGHT

multiple of 11

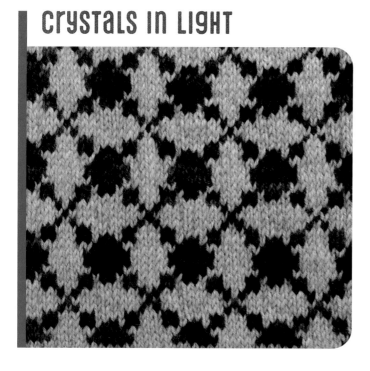

11-st rep

multiple of 14+1

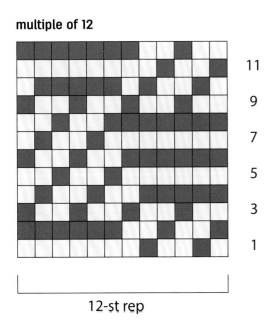

14-st rep

23
21
19
17
15
13
11
9
7
5
3
1

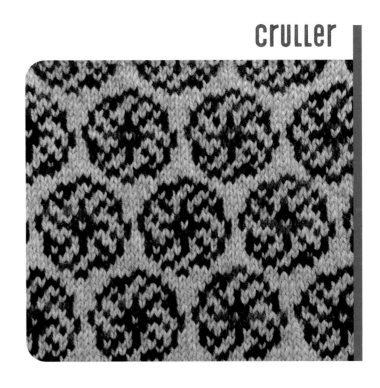

multiple of 12

11
9
7
5
3
1

12-st rep

ELEVATION

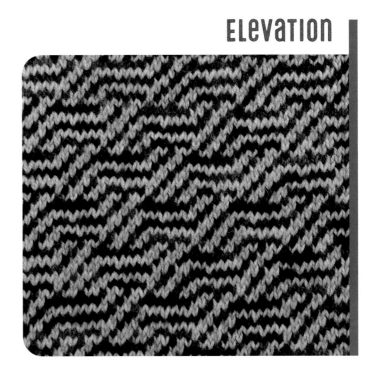

zinnia

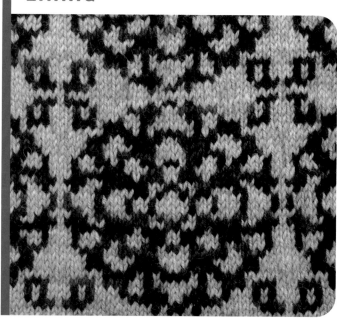

multiple of 29+1

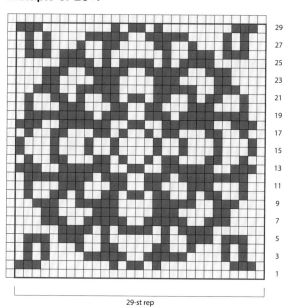

29-st rep

sprig

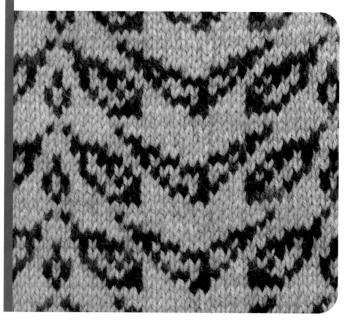

multiple of 30+1

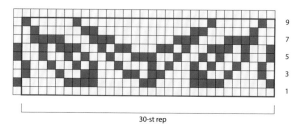

30-st rep

multiple of 11

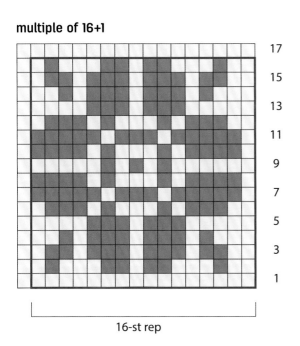

11-st rep

multiple of 16+1

16-st rep

HEDGE OF THORNS

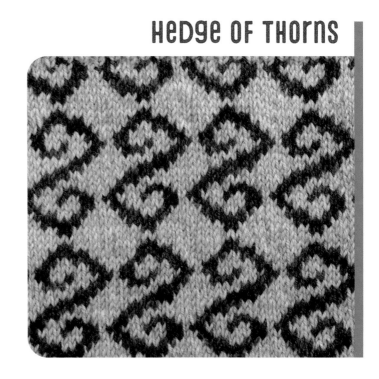

camissonia

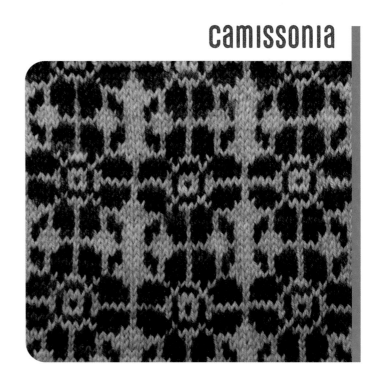

TWIST

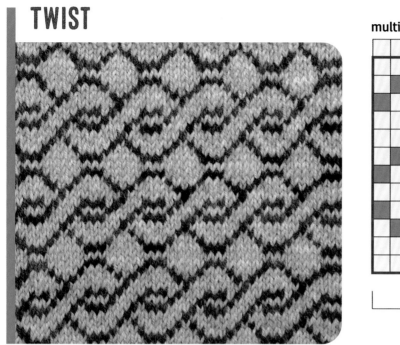

multiple of 8

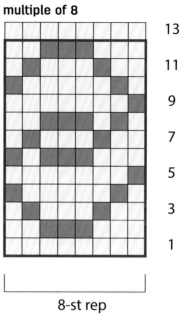

13
11
9
7
5
3
1

8-st rep

EBB AND FLOW

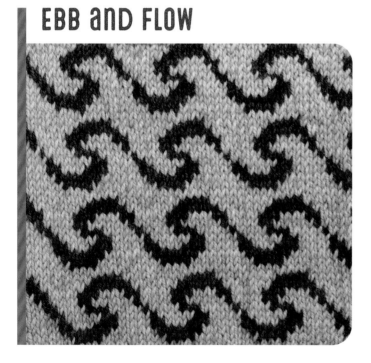

multiple of 12

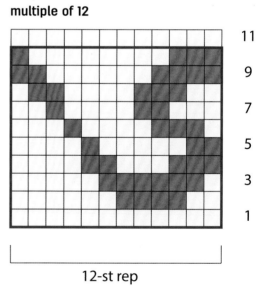

11
9
7
5
3
1

12-st rep

multiple of 11

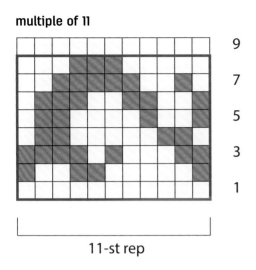

9
7
5
3
1

11-st rep

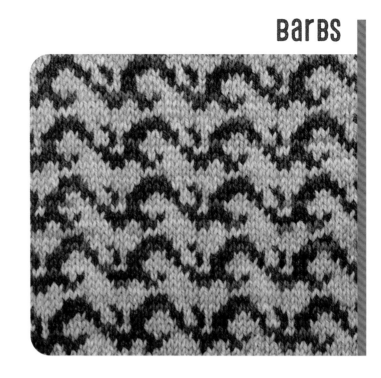

multiple of 16+1

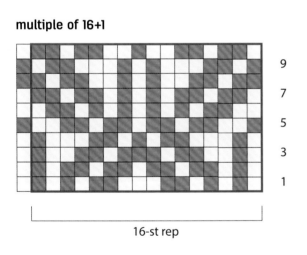

9
7
5
3
1

16-st rep

MAP OF MOUNTAINS

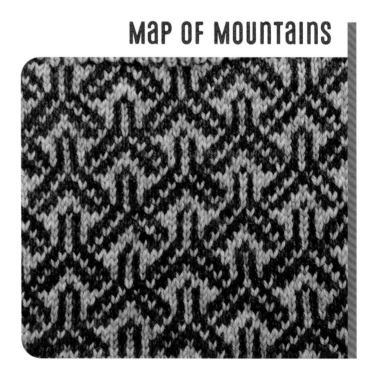

CHRYSANTHEMUM

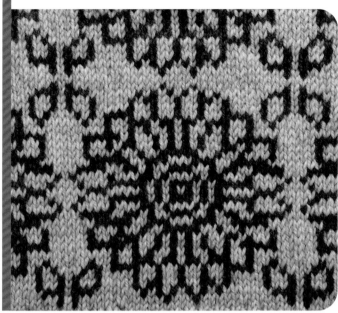

multiple of 30+1

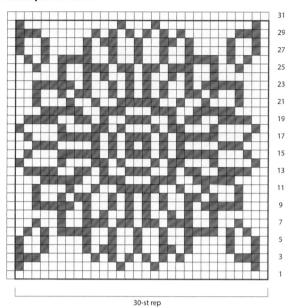

30-st rep

LEAVES IN THE WIND

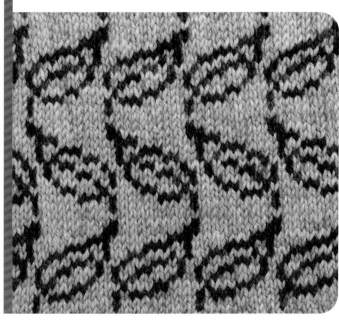

multiple of 10

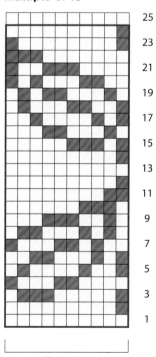

10-st rep

multiple of 30+1

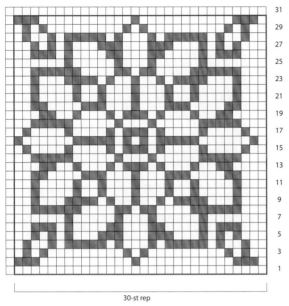

30-st rep

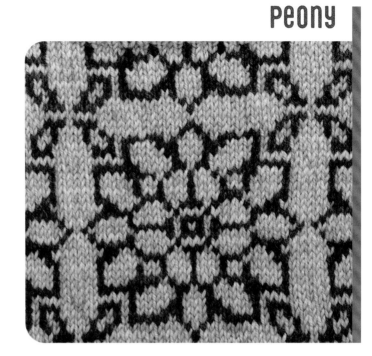

multiple of 21+1

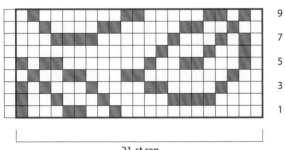

21-st rep

WINTER IS COMING

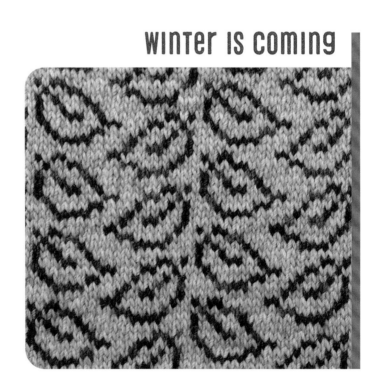

DISTANT TREES

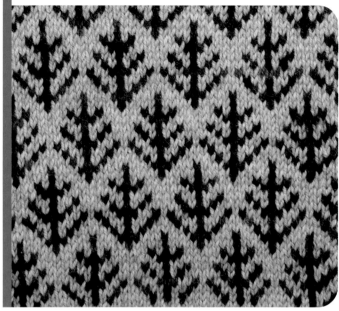

multiple of 10+1

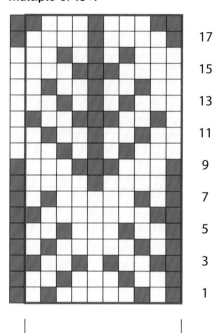

17
15
13
11
9
7
5
3
1

10-st rep

FORGOTTEN HISTORY

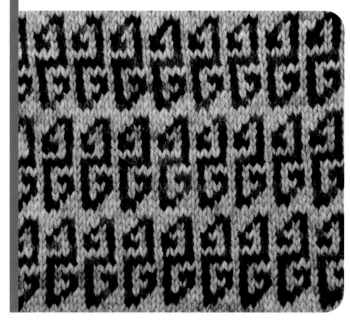

multiple of 5+1

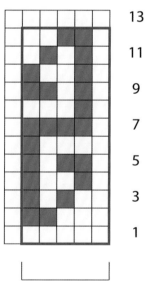

13
11
9
7
5
3
1

5-st rep

multiple of 10

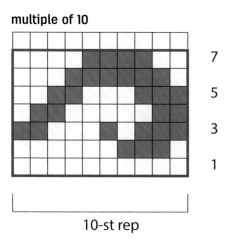

7

5

3

1

10-st rep

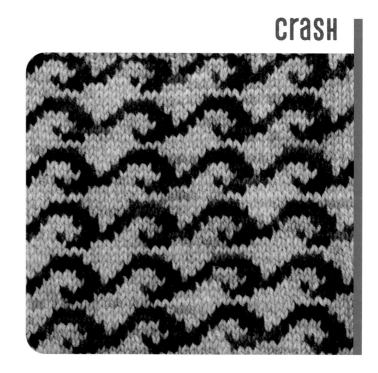

multiple of 6

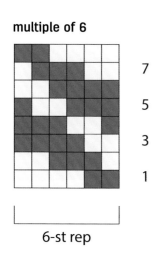

7

5

3

1

6-st rep

RIFT

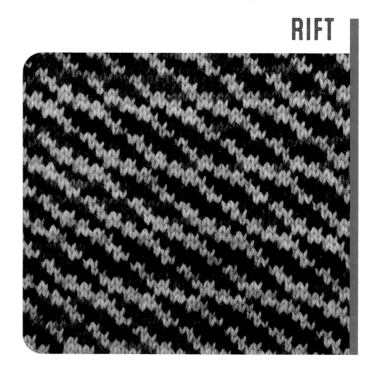

Iron Leaf

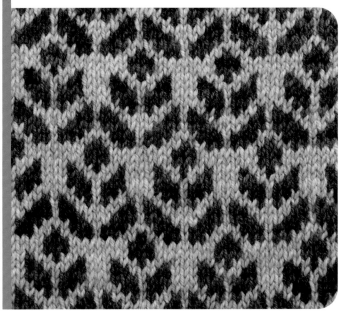

multiple of 10+1

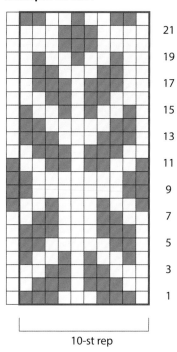

21
19
17
15
13
11
9
7
5
3
1

10-st rep

Acropolis

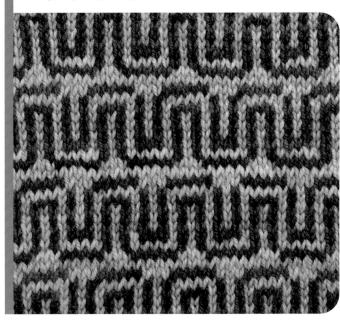

multiple of 8

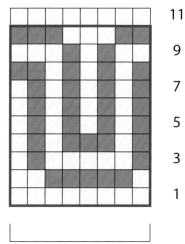

11
9
7
5
3
1

8-st rep

multiple of 31

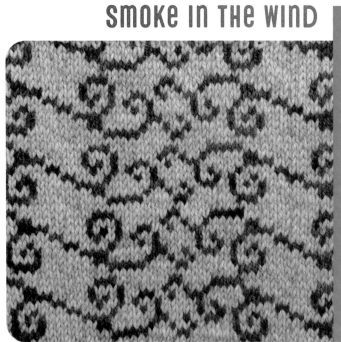

9
7
5
3
1

31-st rep

SMOKE IN THE WIND

multiple of 10+1

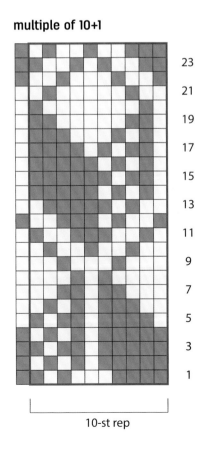

23

21

19

17

15

13

11

9

7

5

3

1

10-st rep

CITY BLOCK

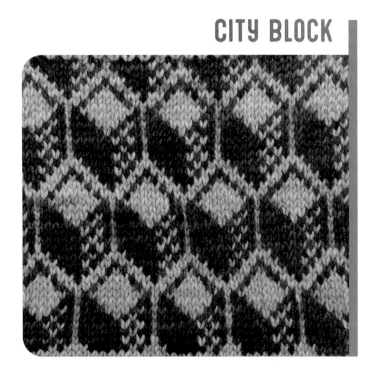

Fresco

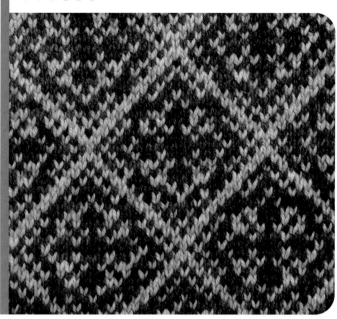

multiple of 22+1

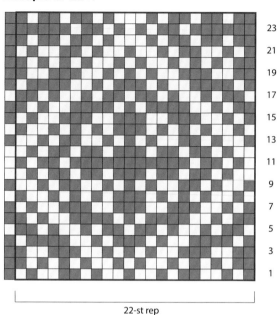

23
21
19
17
15
13
11
9
7
5
3
1

22-st rep

Trailblazer

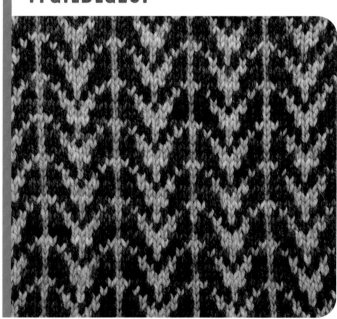

multiple of 10+1

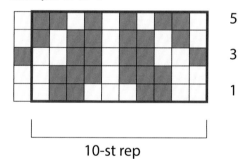

5

3

1

10-st rep

multiple of 22+1

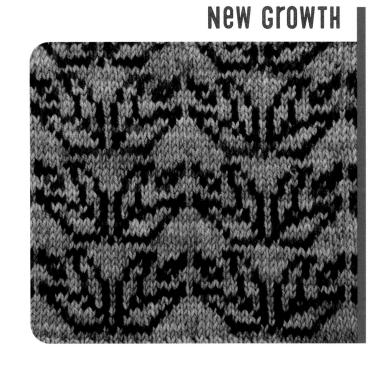

13
11
9
7
5
3
1

22-st rep

multiple of 14

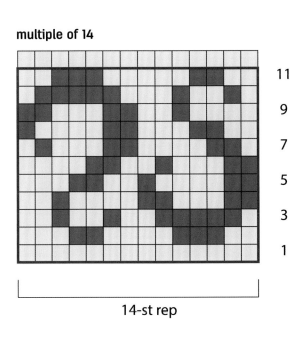

11
9
7
5
3
1

14-st rep

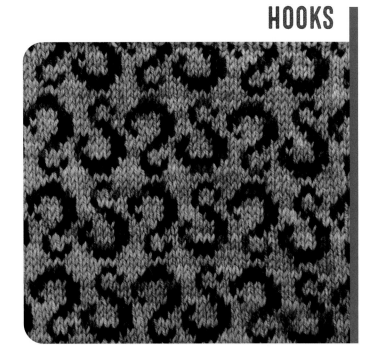

Pavo

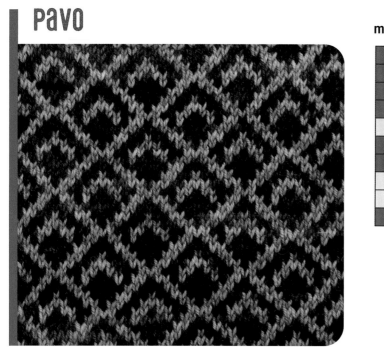

multiple of 12+1

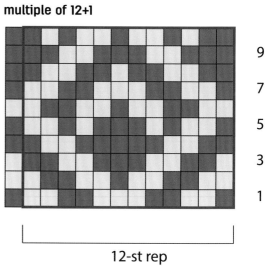

9

7

5

3

1

12-st rep

Artemis

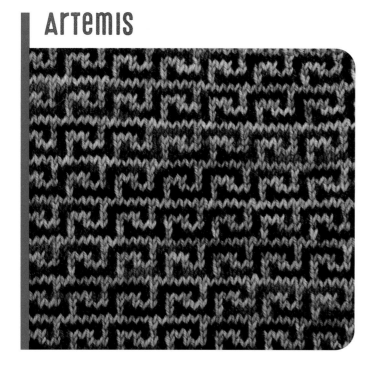

multiple of 6

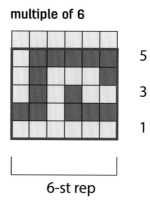

5

3

1

6-st rep

multiple of 18

15
13
11
9
7
5
3
1

18-st rep

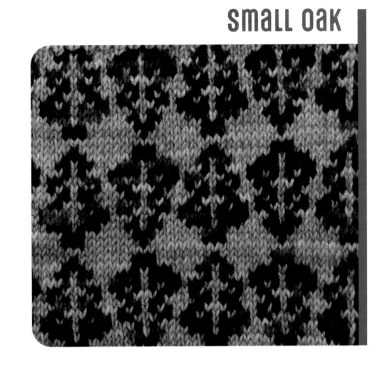

multiple of 18+1

9
7
5
3
1

18-st rep

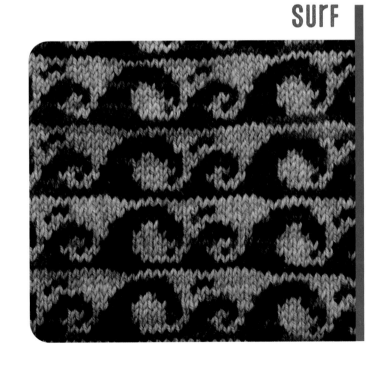

Beginnings

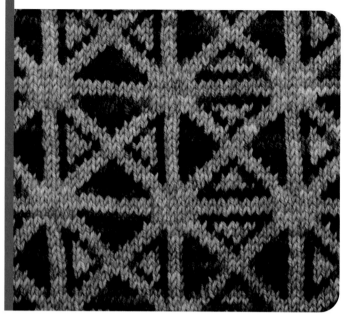

multiple of 30+2

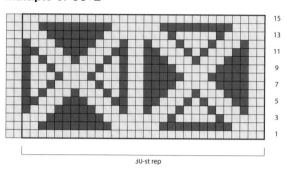

30-st rep

15
13
11
9
7
5
3
1

Circuit

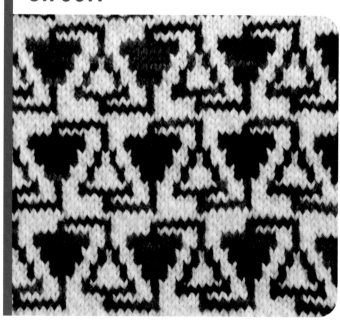

multiple of 12

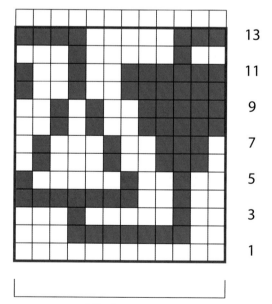

13
11
9
7
5
3
1

12-st rep

multiple of 10

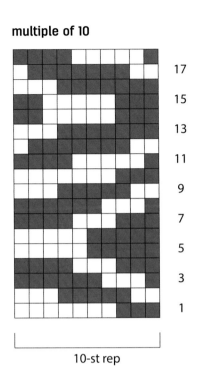

17

15

13

11

9

7

5

3

1

10-st rep

multiple of 13

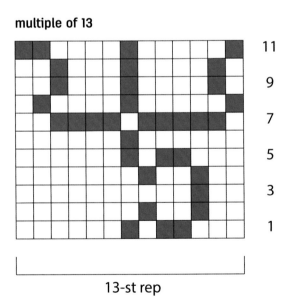

11

9

7

5

3

1

13-st rep

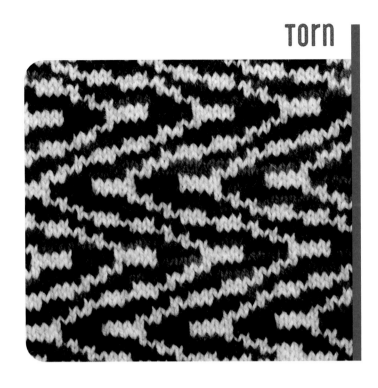

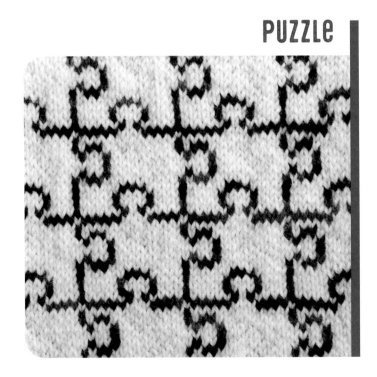

FLUrry

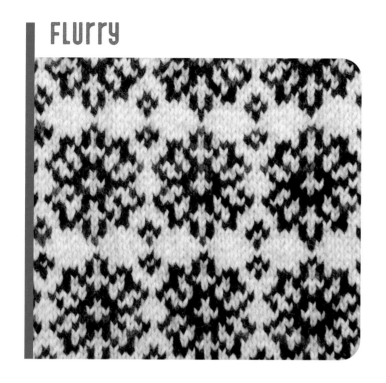

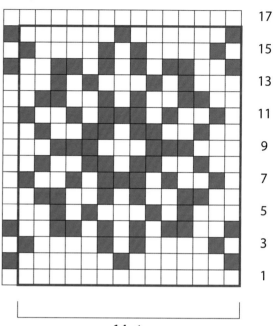

17
15
13
11
9
7
5
3
1

14-st rep

ceramic

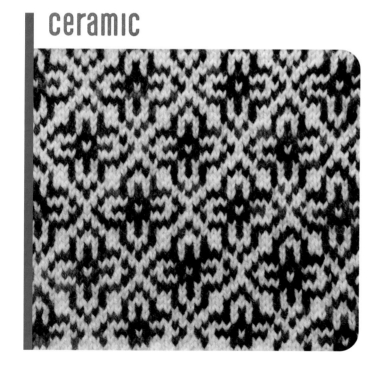

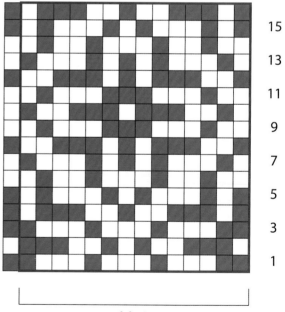

15
13
11
9
7
5
3
1

14-st rep

multiple of 18+1

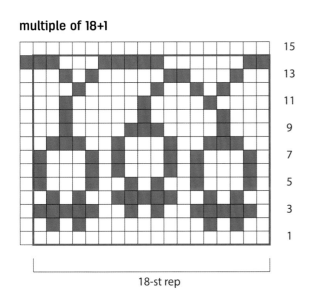

15
13
11
9
7
5
3
1

18-st rep

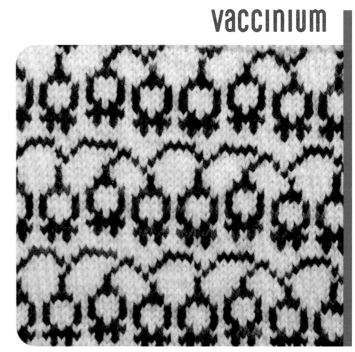

multiple of 22+1

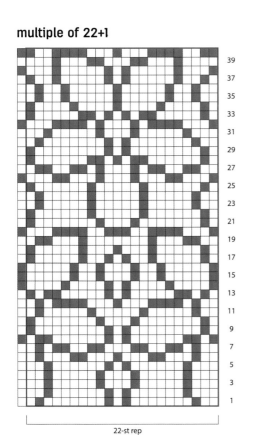

39
37
35
33
31
29
27
25
23
21
19
17
15
13
11
9
7
5
3
1

22-st rep

vanilla orchid

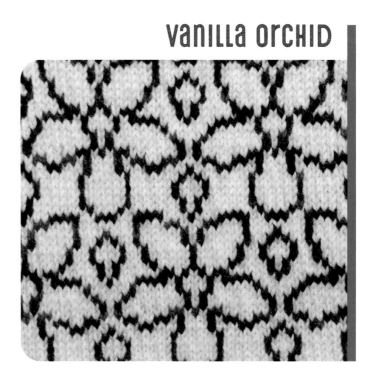

WIND

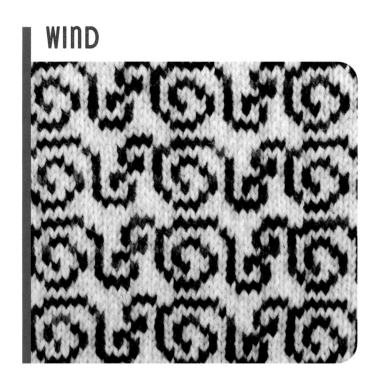

multiple of 15

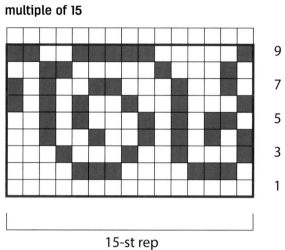

15-st rep

CRESCENT MOON

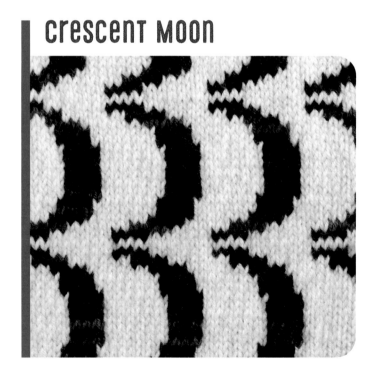

multiple of 11+1

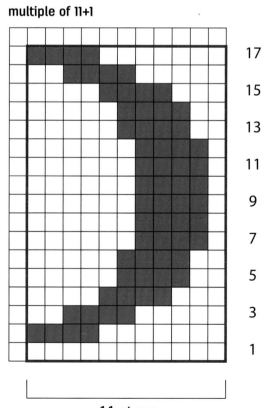

11-st rep

multiple of 16

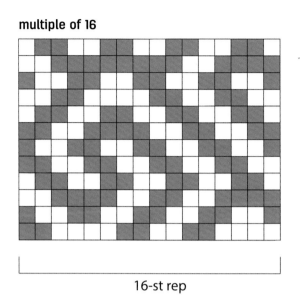

16-st rep

multiple of 8+1

5

3

1

8-st rep

CRIMP

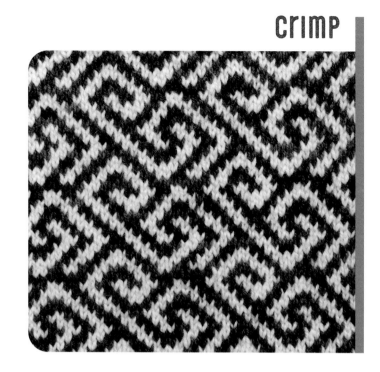

RISE

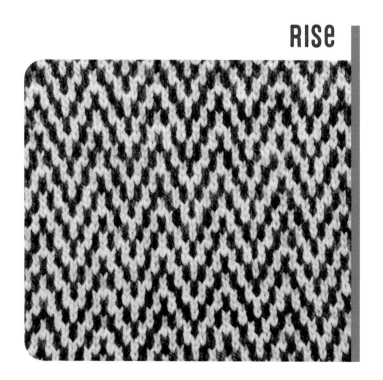

forever

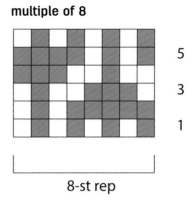

multiple of 8

5

3

1

8-st rep

fortress

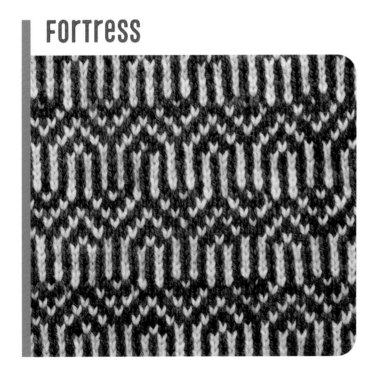

multiple of 8+1

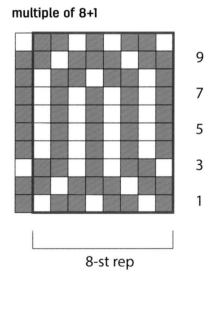

9

7

5

3

1

8-st rep

multiple of 10+1

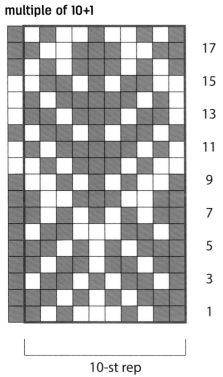

17

15

13

11

9

7

5

3

1

10-st rep

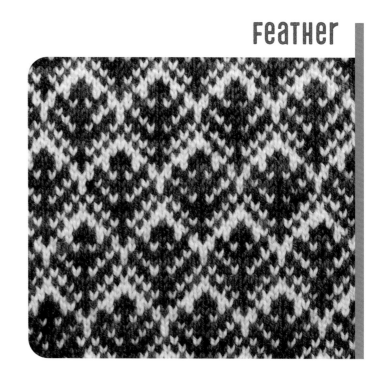

multiple of 16

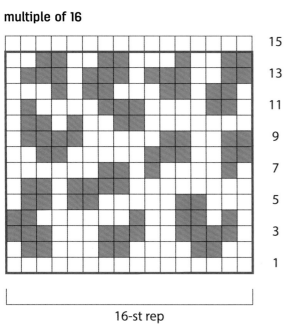

15

13

11

9

7

5

3

1

16-st rep

CHEETAH

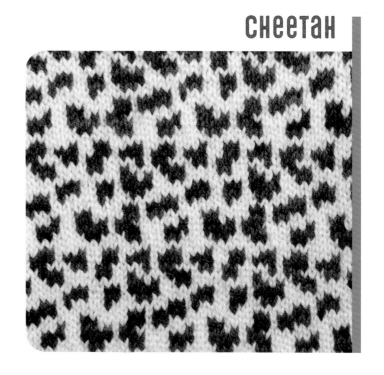

TreLLIS

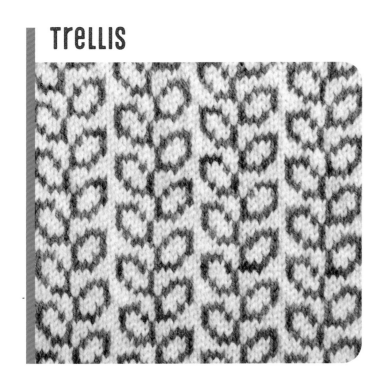

multiple of 11+1

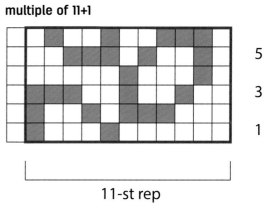

11-st rep

Large OaK

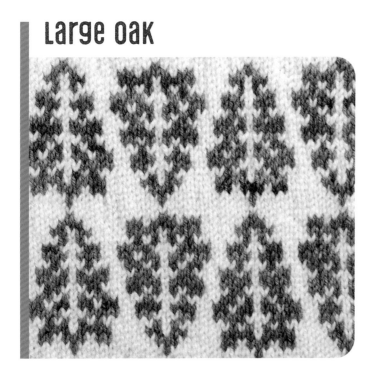

multiple of 22

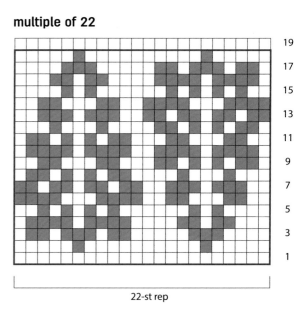

22-st rep

multiple of 29+1

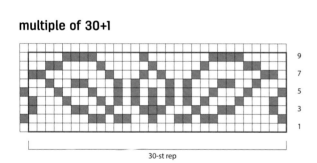

29-st rep

13
11
9
7
5
3
1

SIGNS OF SPRING

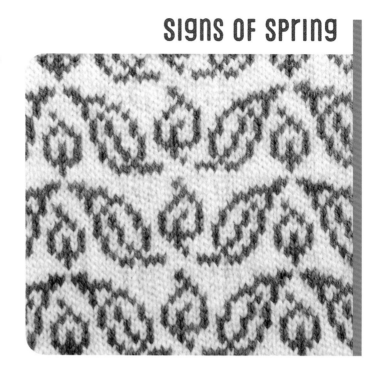

LAYERS OF LEAVES

multiple of 30+1

30-st rep

9
7
5
3
1

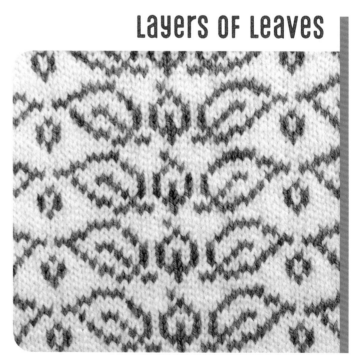

Bramble

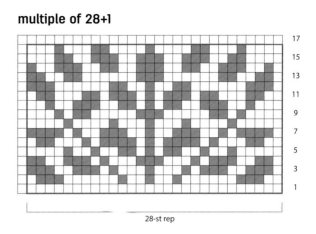

multiple of 28+1

17
15
13
11
9
7
5
3
1

28-st rep

THICKET

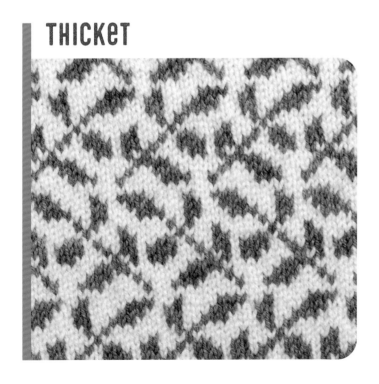

multiple of 10

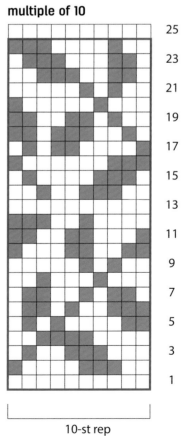

25
23
21
19
17
15
13
11
9
7
5
3
1

10-st rep

multiple of 18+1

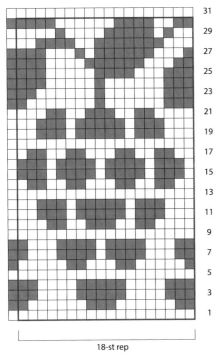

31
29
27
25
23
21
19
17
15
13
11
9
7
5
3
1

18-st rep

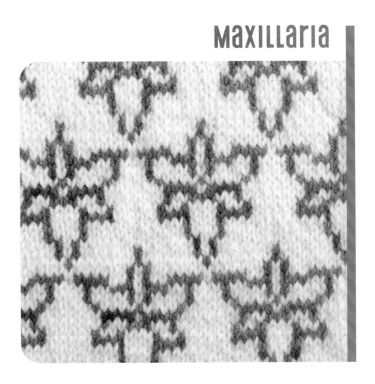

multiple of 16+1

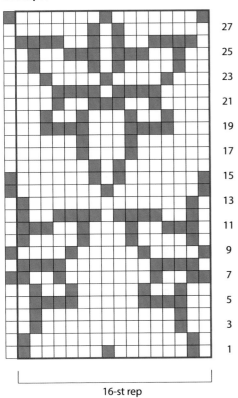

27
25
23
21
19
17
15
13
11
9
7
5
3
1

16-st rep

MONSTERA

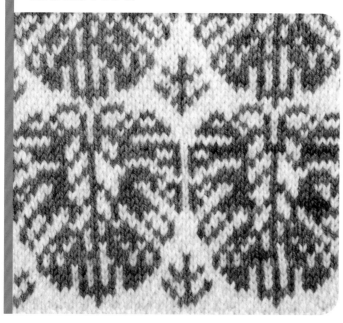

multiple of 24+1

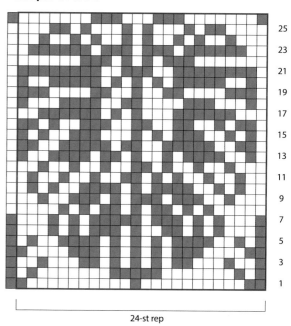

25
23
21
19
17
15
13
11
9
7
5
3
1

24-st rep

HEMP

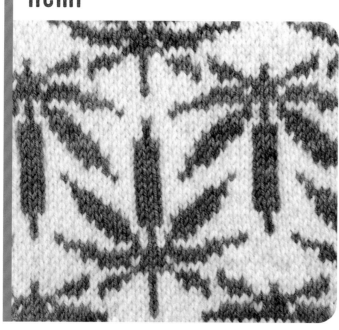

multiple of 28+5

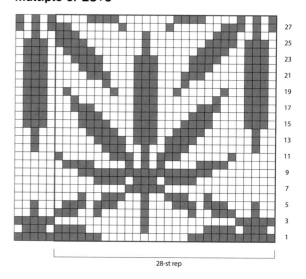

27
25
23
21
19
17
15
13
11
9
7
5
3
1

28-st rep

multiple of 32+1

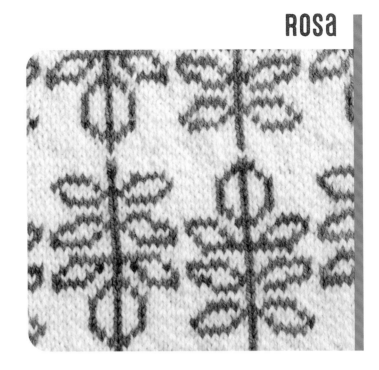

ROSA

25
23
21
19
17
15
13
11
9
7
5
3
1

32-st rep

multiple of 22

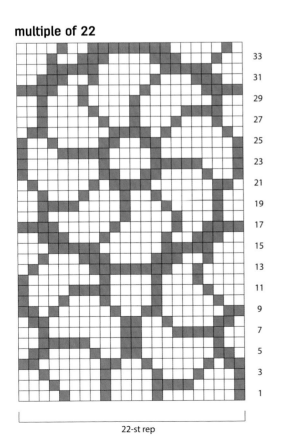

STONECROP

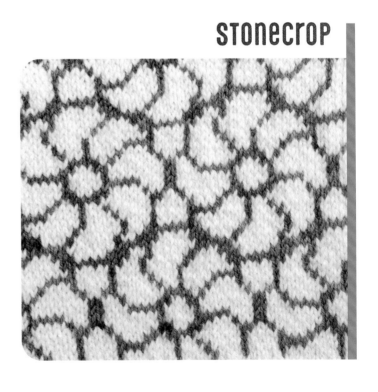

33
31
29
27
25
23
21
19
17
15
13
11
9
7
5
3
1

22-st rep

VINE MAPLE

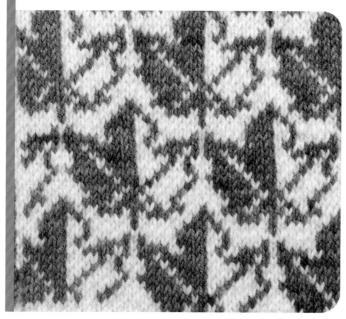

multiple of 18+1

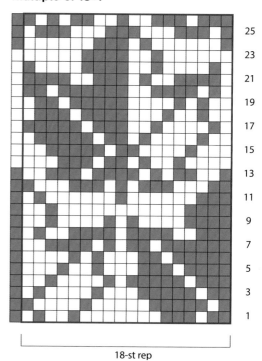

25
23
21
19
17
15
13
11
9
7
5
3
1

18-st rep

EDGE OF THE EARTH

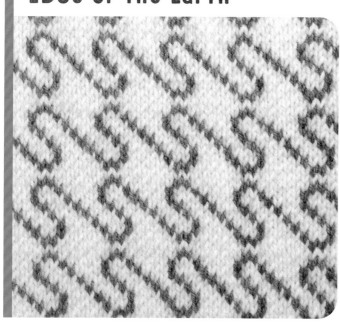

multiple of 8

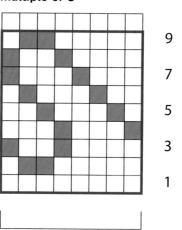

9
7
5
3
1

8-st rep

multiple of 31

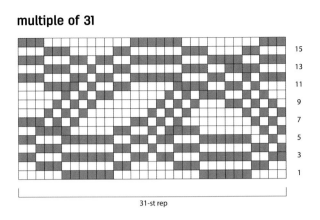

15
13
11
9
7
5
3
1

31-st rep

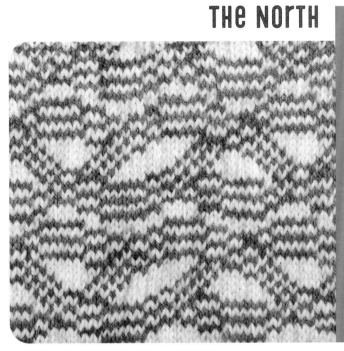

multiple of 16+1

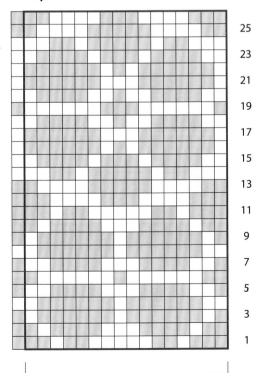

25
23
21
19
17
15
13
11
9
7
5
3
1

16-st rep

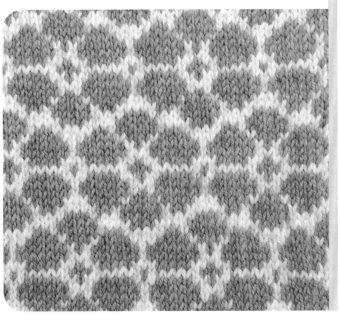

SUNFLOWER

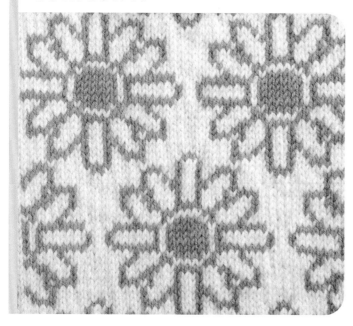

multiple of 26

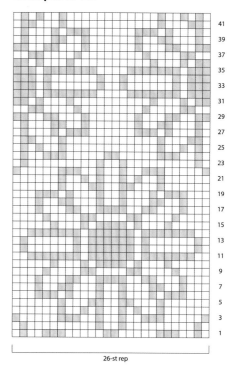

26-st rep

BRASSICA

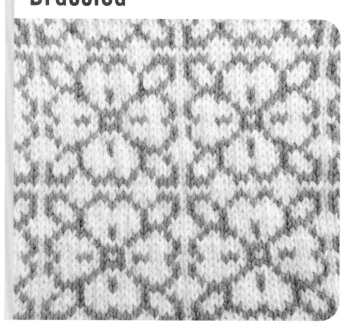

multiple of 18+1

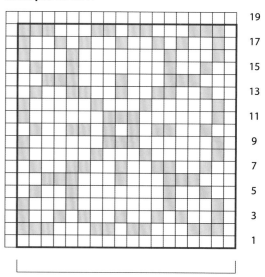

18-st rep

multiple of 26+1

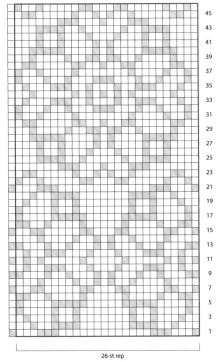

45
43
41
39
37
35
33
31
29
27
25
23
21
19
17
15
13
11
9
7
5
3
1

26-st rep

multiple of 14

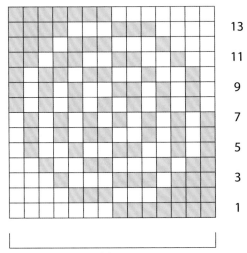

13

11

9

7

5

3

1

14-st rep

MARIGOLD

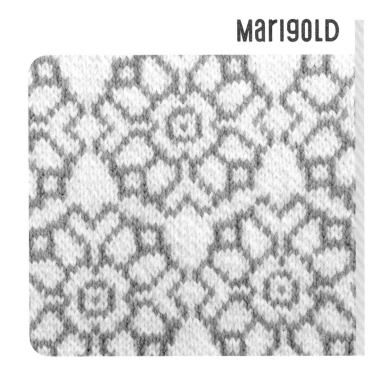

MULTIVERSE

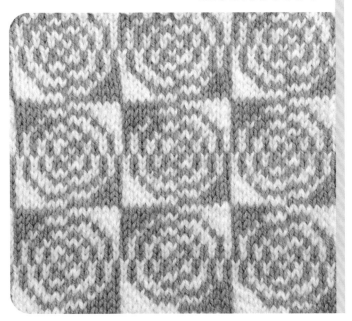

CHERRIES

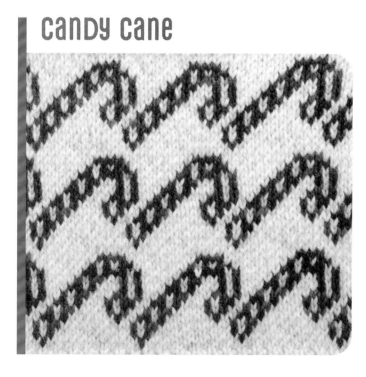

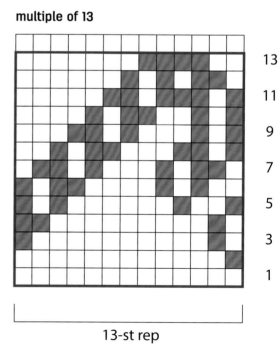

19
17
15
13
11
9
7
5
3
1

15-st rep

CANDY CANE

multiple of 13

13
11
9
7
5
3
1

13-st rep

multiple of 18

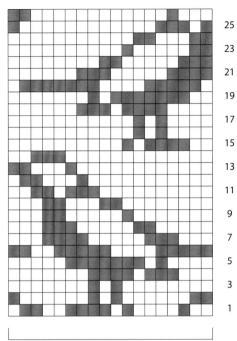

25
23
21
19
17
15
13
11
9
7
5
3
1

18-st rep

multiple of 20

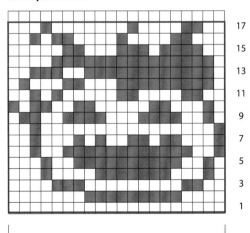

17
15
13
11
9
7
5
3
1

20-st rep

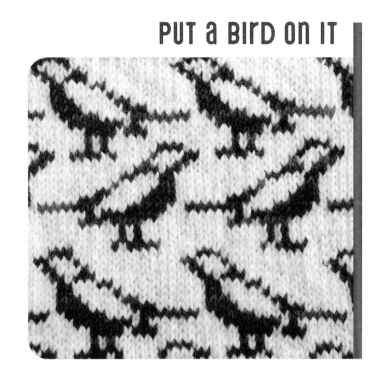

ON THE PORCH

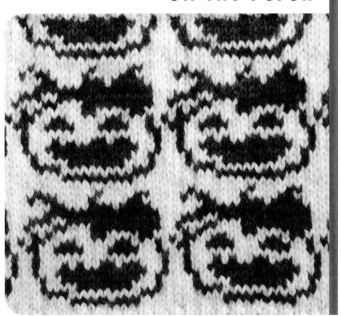

Dragon

multiple of 28+1

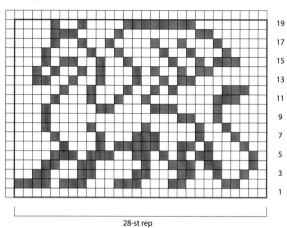

28-st rep

CHEESE VS. MOUSE

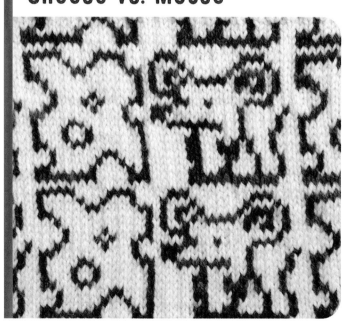

multiple of 35+1

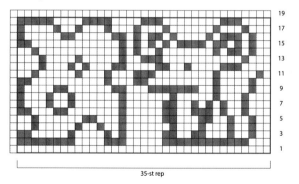

35-st rep

multiple of 26

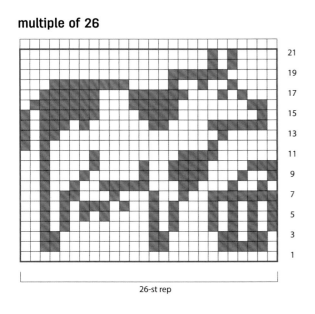

26-st rep

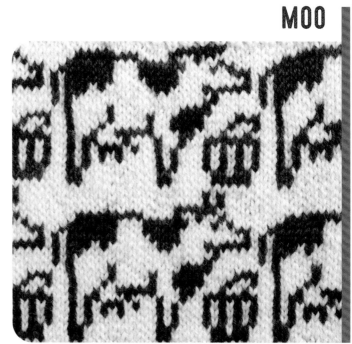

multiple of 26

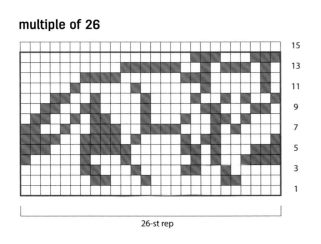

26-st rep

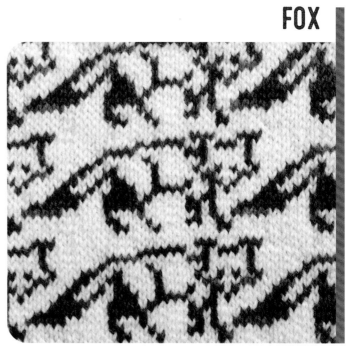

scorpion

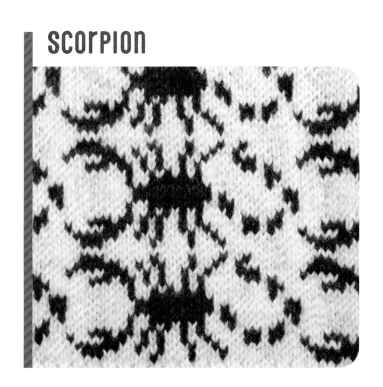

multiple of 30

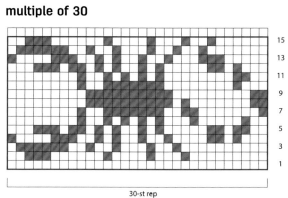

30-st rep

Tiny Pony

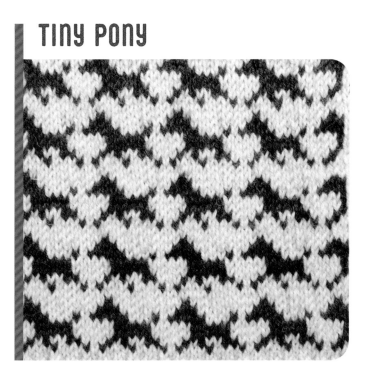

multiple of 10

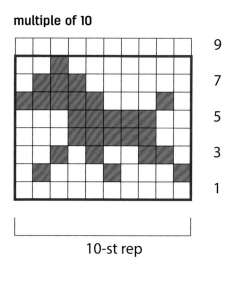

10-st rep

multiple of 20+1

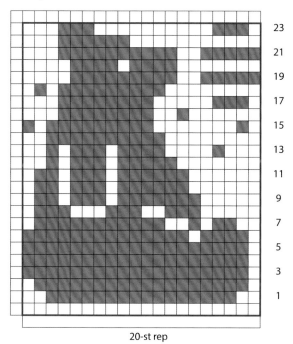

23
21
19
17
15
13
11
9
7
5
3
1

20-st rep

PONDERING BEAR

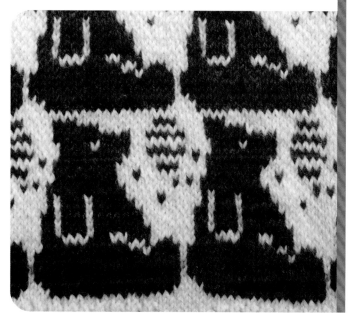

multiple of 10+1

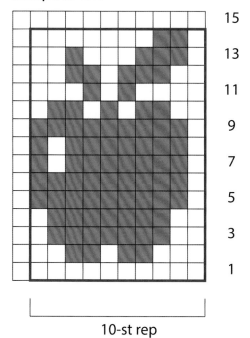

15
13
11
9
7
5
3
1

10-st rep

APPLE

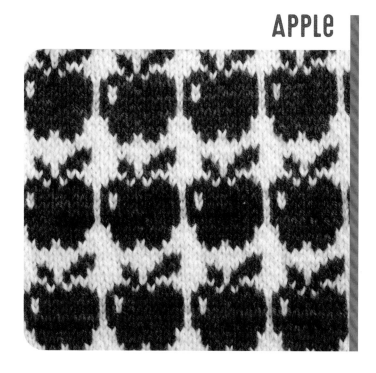

LIPS

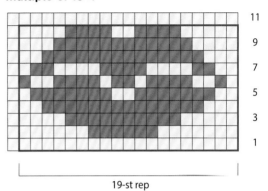

multiple of 19+1

19-st rep

STRAWBERRIES

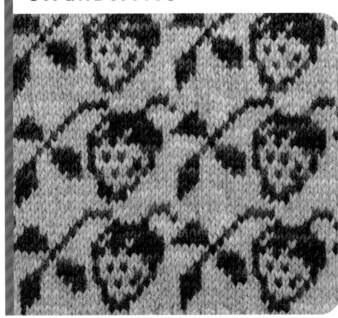

multiple of 22

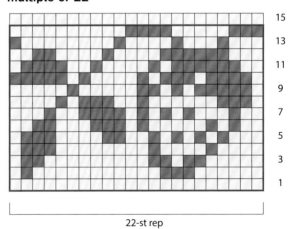

22-st rep

multiple of 12+1

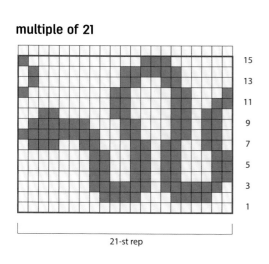

12-st rep

11
9
7
5
3
1

SMALL CRAB

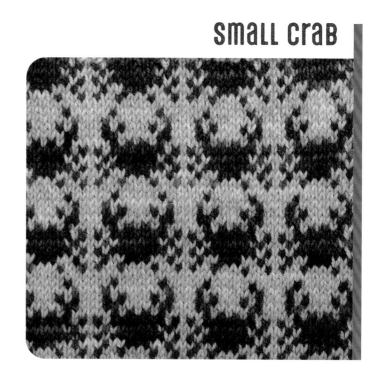

SNAKES

multiple of 21

15
13
11
9
7
5
3
1

21-st rep

SPOT OF TEA

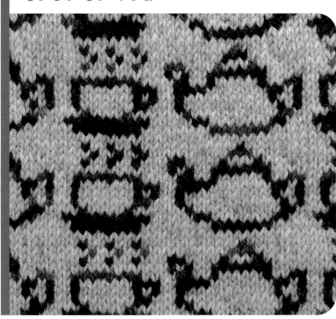

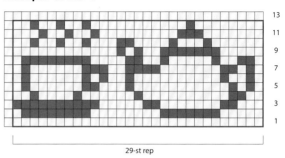

13
11
9
7
5
3
1

29-st rep

A FOOT'S BEST FRIEND

multiple of 8+1

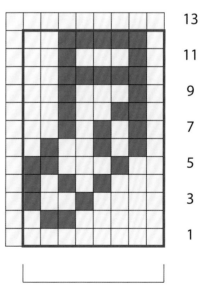

13
11
9
7
5
3
1

8-st rep

multiple of 24+1

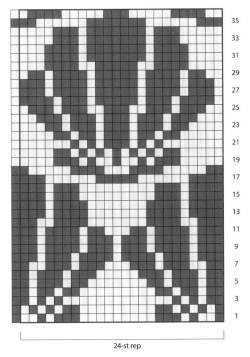

35
33
31
29
27
25
23
21
19
17
15
13
11
9
7
5
3
1

24-st rep

multiple of 20+1

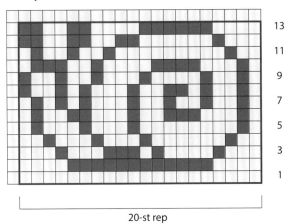

13
11
9
7
5
3
1

20-st rep

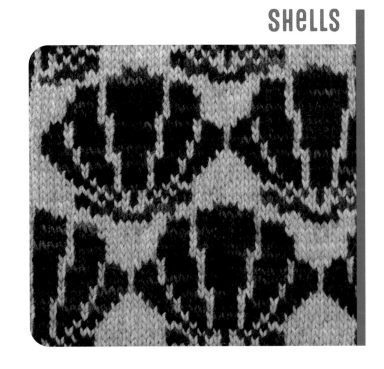

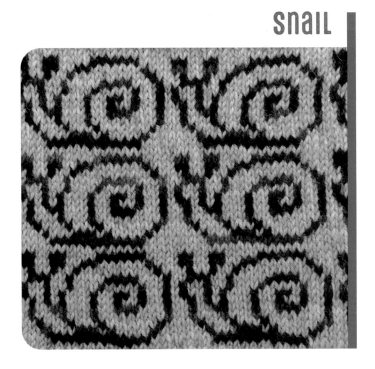

BOW

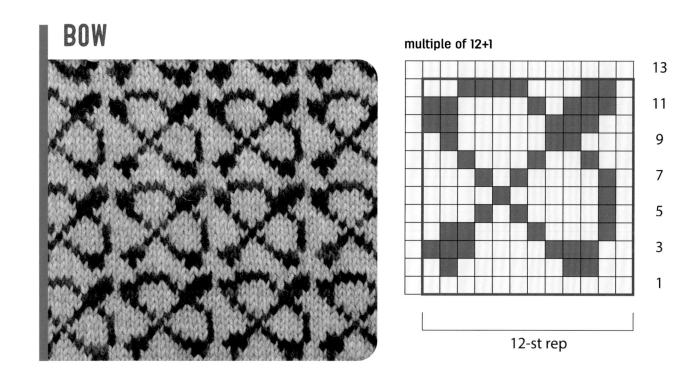

multiple of 12+1

13
11
9
7
5
3
1

12-st rep

LITTLE YAPPY

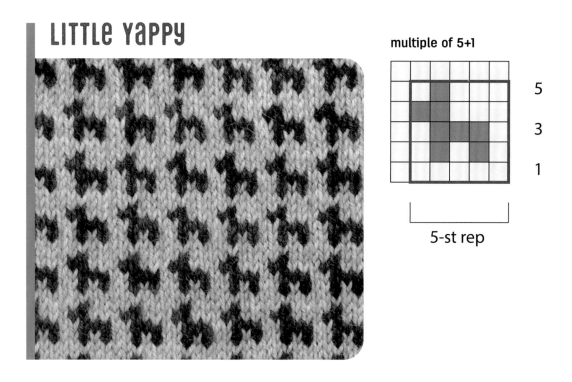

multiple of 5+1

5
3
1

5-st rep

multiple of 13+1

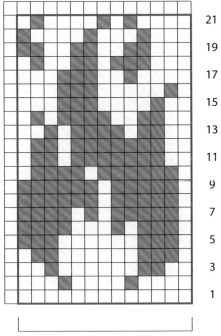

21
19
17
15
13
11
9
7
5
3
1

13-st rep

multiple of 18+1

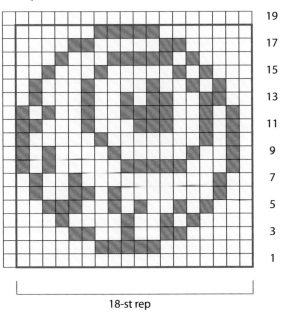

19
17
15
13
11
9
7
5
3
1

18-st rep

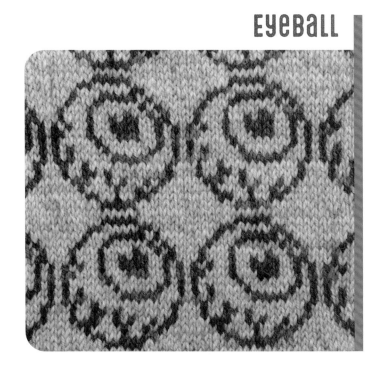

GINGERBREAD PERSON

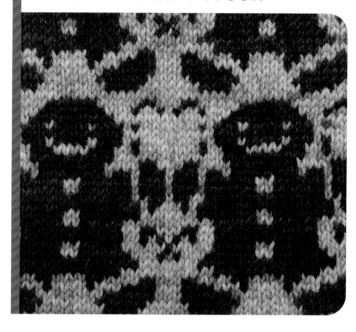

multiple of 23+1

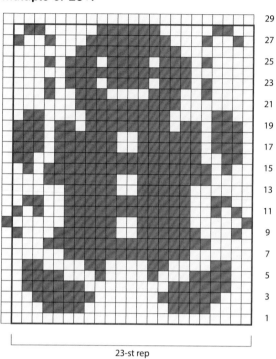

23-st rep

BIG CRAB

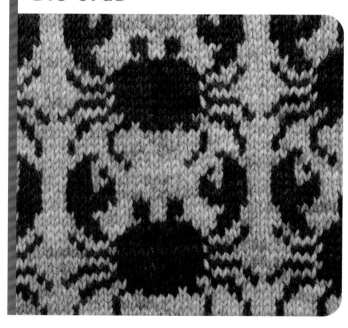

multiple of 25+1

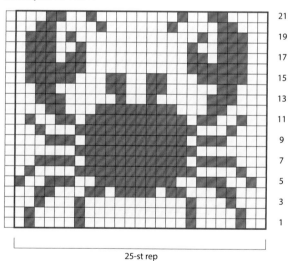

25-st rep

multiple of 10+1

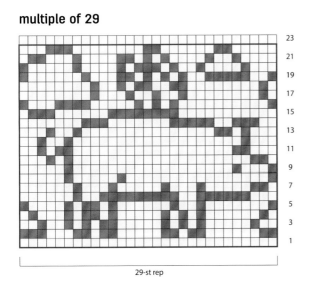

19
17
15
13
11
9
7
5
3
1

10-st rep

multiple of 29

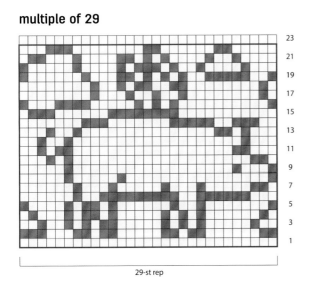

23
21
19
17
15
13
11
9
7
5
3
1

29-st rep

Garden Gnome

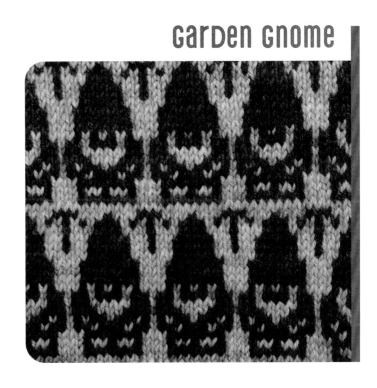

JUST A LITTLE AIRBORNE

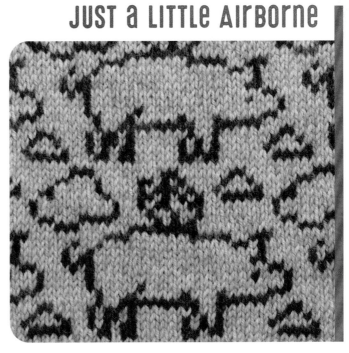

POST-APOCALYPTIC

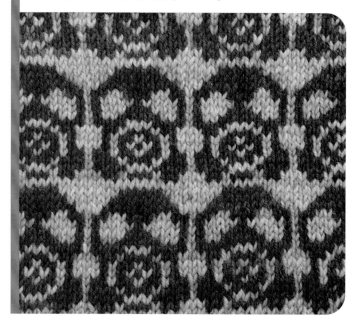

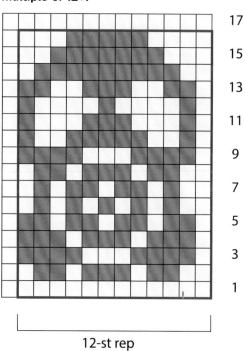

multiple of 12+1

17
15
13
11
9
7
5
3
1

12-st rep

BOOT

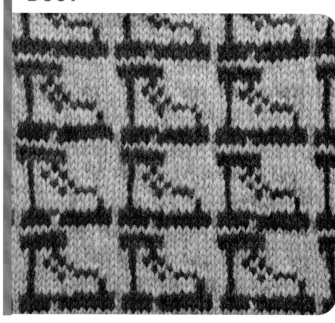

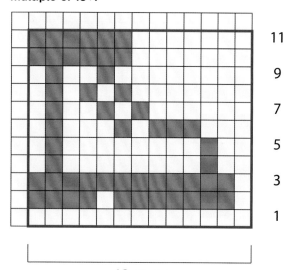

multiple of 13+1

11
9
7
5
3
1

13-st rep

multiple of 22

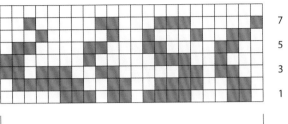

7
5
3
1

22-st rep

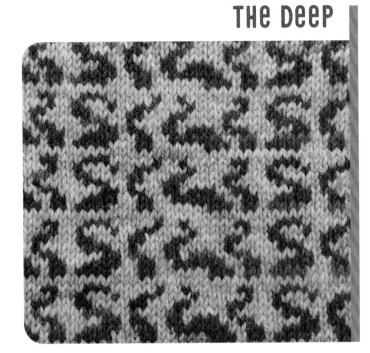

multiple of 14+1

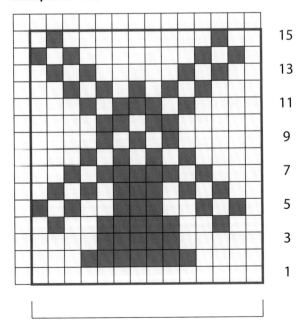

15
13
11
9
7
5
3
1

14-st rep

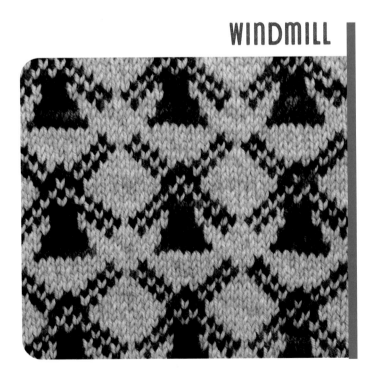

DOLPHIN

multiple of 31+2

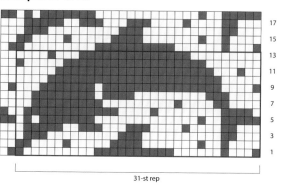

17
15
13
11
9
7
5
3
1

31-st rep

TOILET BOUND

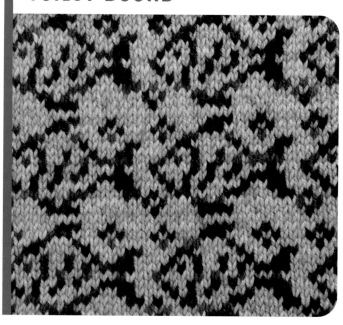

multiple of 18

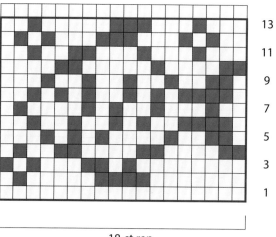

13
11
9
7
5
3
1

18-st rep

multiple of 12+1

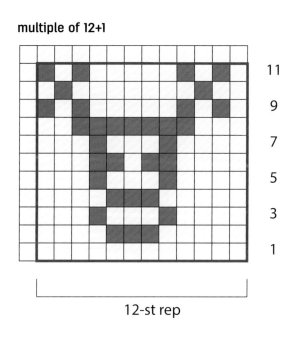

11

9

7

5

3

1

12-st rep

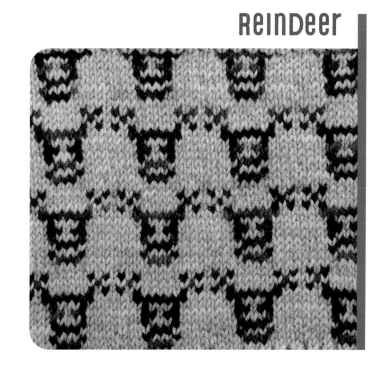

multiple of 12+1

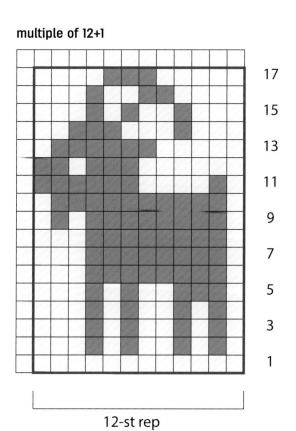

17

15

13

11

9

7

5

3

1

12-st rep

AH, GOATLEY

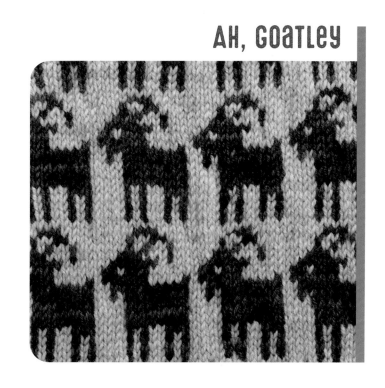

Rat

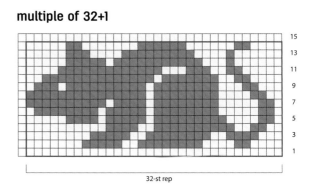

multiple of 32+1

15
13
11
9
7
5
3
1

32-st rep

Porcelain Throne

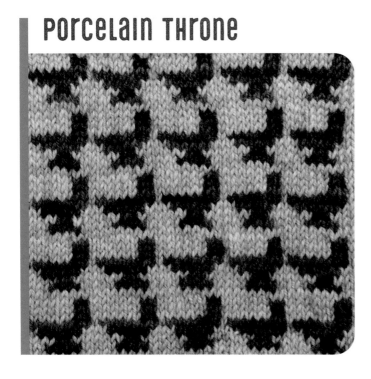

multiple of 8+1

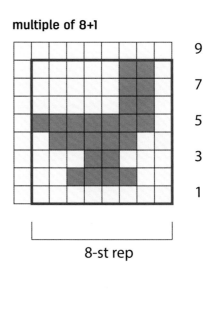

9

7

5

3

1

8-st rep

multiple of 19+1

19
17
15
13
11
9
7
5
3
1

19-st rep

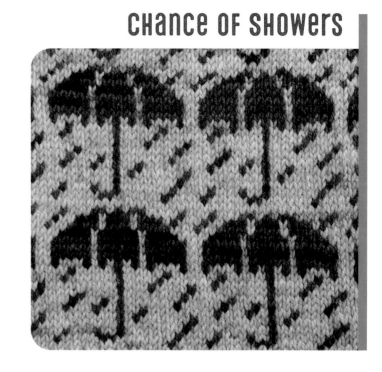

CHANCE OF SHOWERS

multiple of 23+1

7
5
3
1

23-st rep

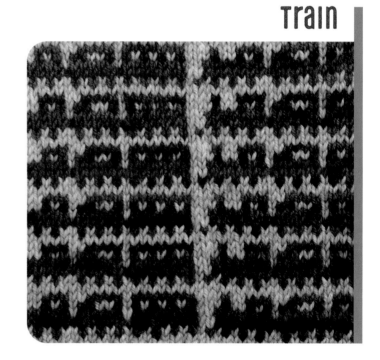

TRAIN

DOWN DOG

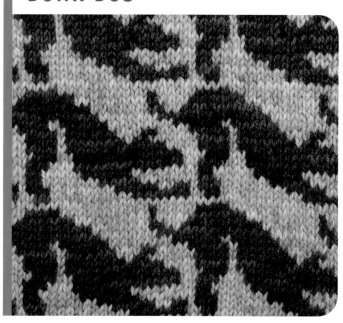

multiple of 21

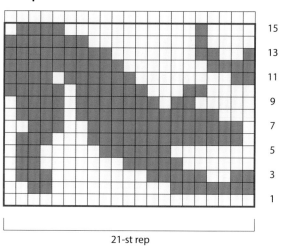

15
13
11
9
7
5
3
1

21-st rep

PLANE

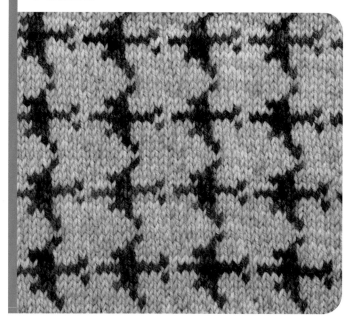

multiple of 10+1

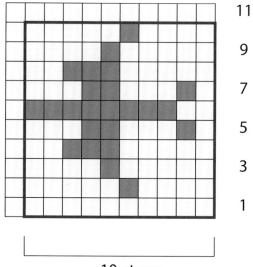

11
9
7
5
3
1

10-st rep

multiple of 10+1

11

9

7

5

3

1

10-st rep

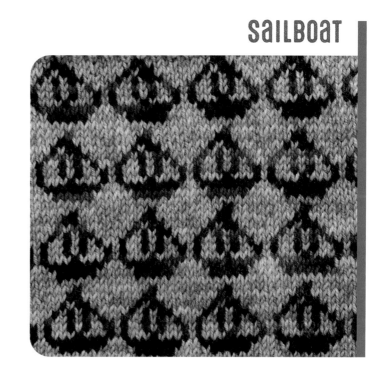

multiple of 37+1

7 5 3 1

37-st rep

MOON PHASES

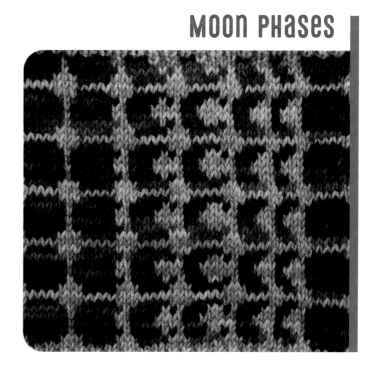

snow person

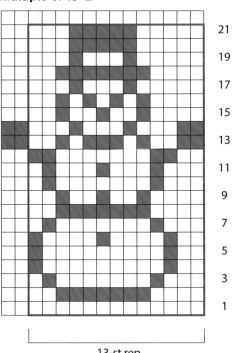

multiple of 13+2

21
19
17
15
13
11
9
7
5
3
1

13-st rep

MOTH

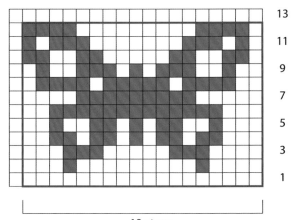

multiple of 18+1

13
11
9
7
5
3
1

18-st rep

multiple of 31

31-st rep

DINOSAURS

multiple of 24+1

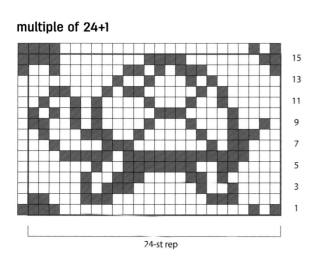

24-st rep

TORTOISE

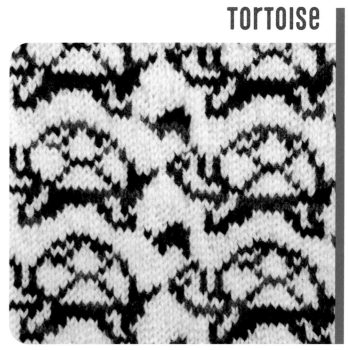

Nautilus

multiple of 22+1

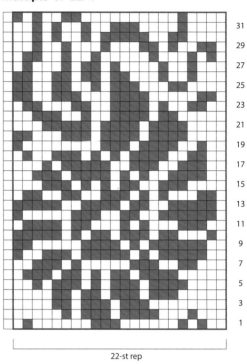

22-st rep

Fairy

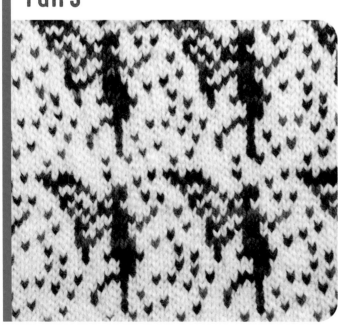

multiple of 17+1

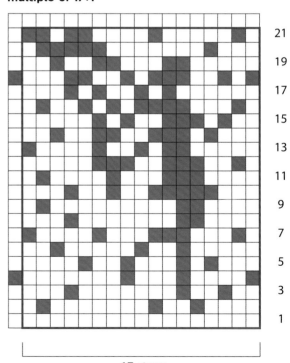

17-st rep

multiple of 16+1

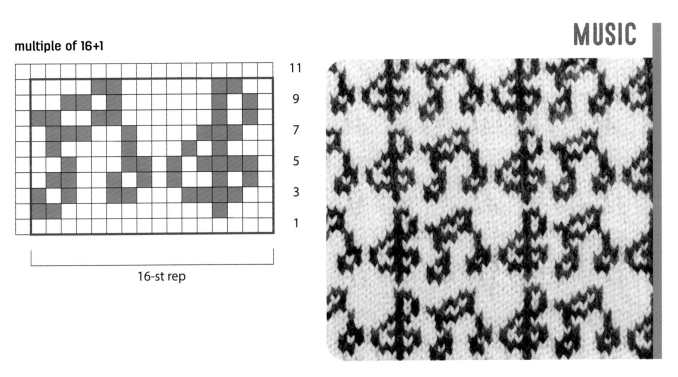

16-st rep

multiple of 13+1

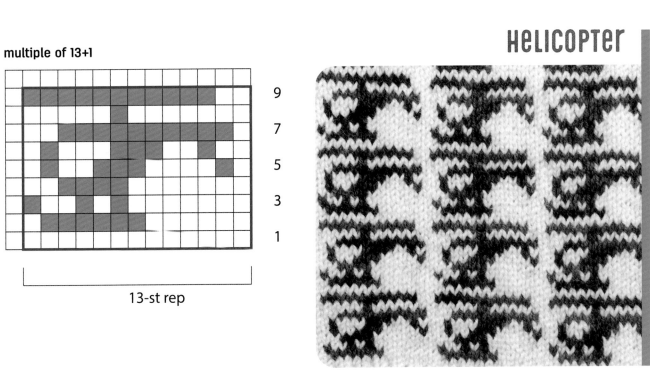

13-st rep

CORPORATE FAT CAT

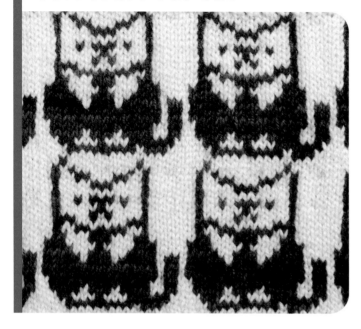

multiple of 19+1

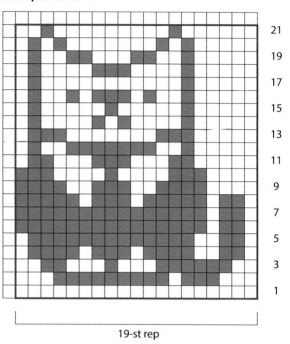

19-st rep

BOHR'S ATOM

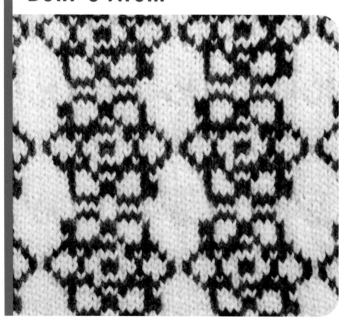

multiple of 17+1

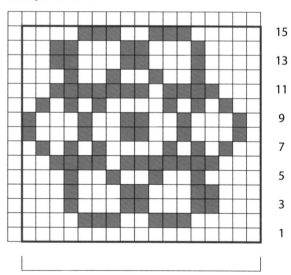

17-st rep

multiple of 17+1

17-st rep

multiple of 48+1

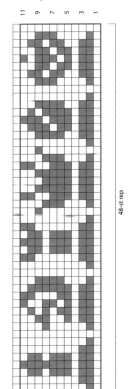

48-st rep

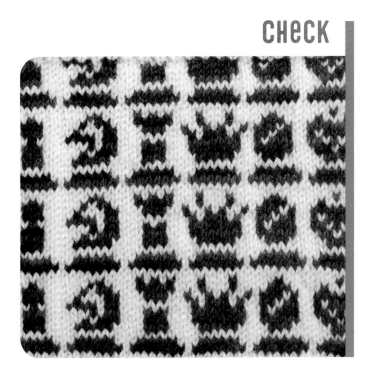

GHOSTS

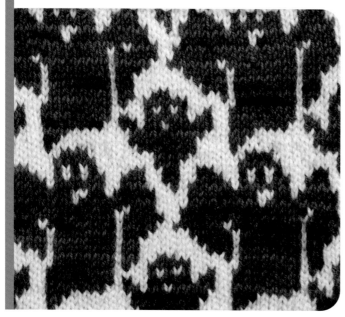

multiple of 22+1

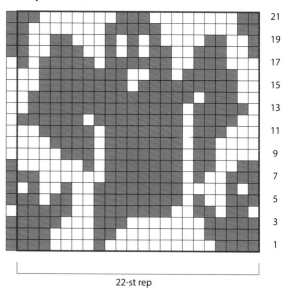

22-st rep

8 BALL

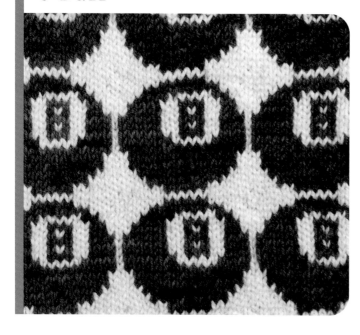

multiple of 16+1

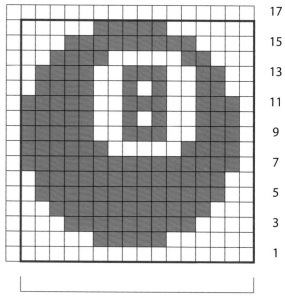

16-st rep

multiple of 12+1

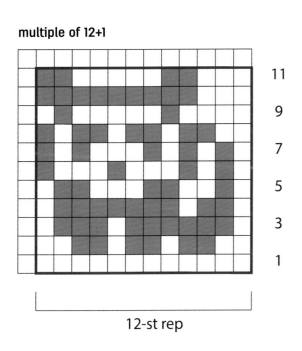

12-st rep

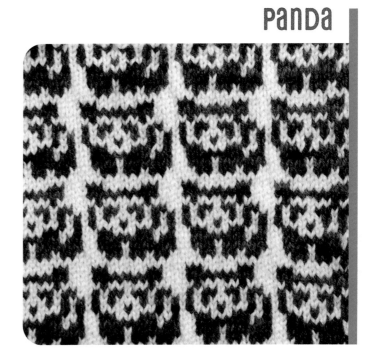

multiple of 12+1

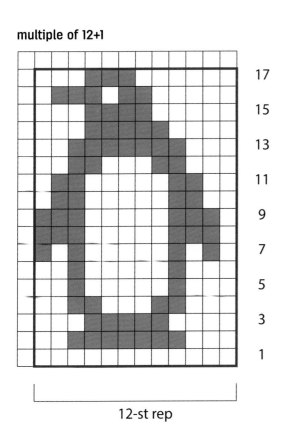

12-st rep

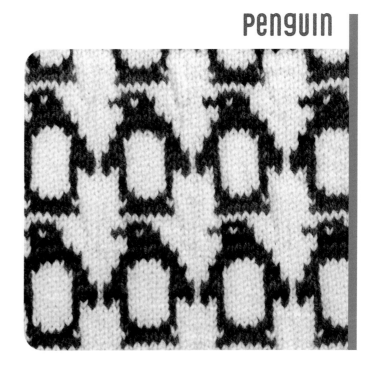

HOME

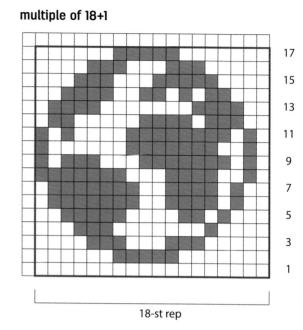

multiple of 18+1

18-st rep

BAG O' MONEY

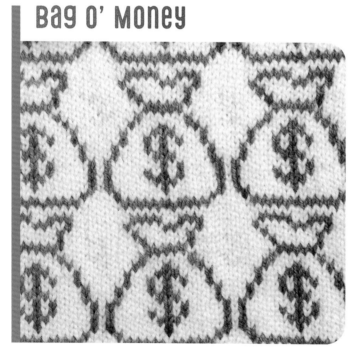

multiple of 16+1

16-st rep

multiple of 17

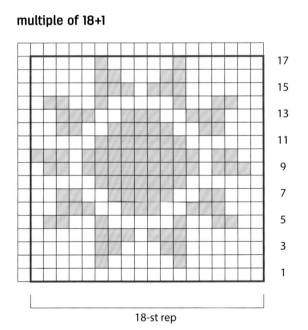

17-st rep

13
11
9
7
5
3
1

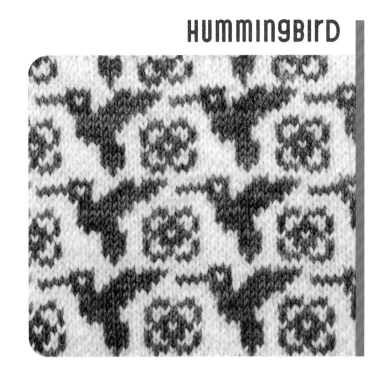

multiple of 18+1

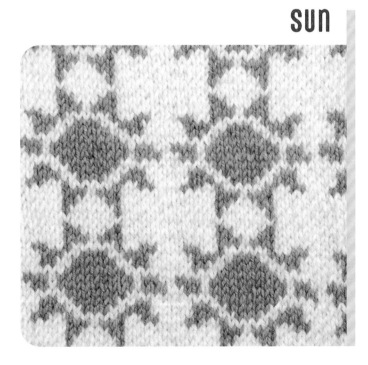

18-st rep

17
15
13
11
9
7
5
3
1

RUBBER DUCKY

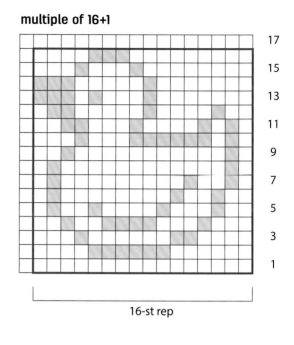

multiple of 16+1

16-st rep

IT'S TOaST

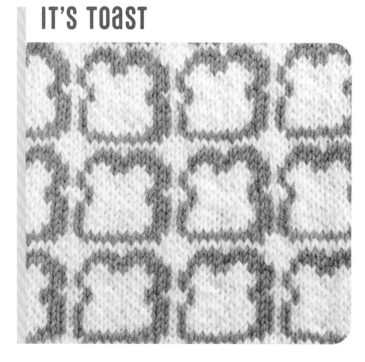

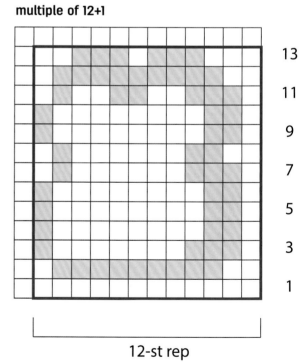

multiple of 12+1

12-st rep

SWATCH COLOR GUIDE

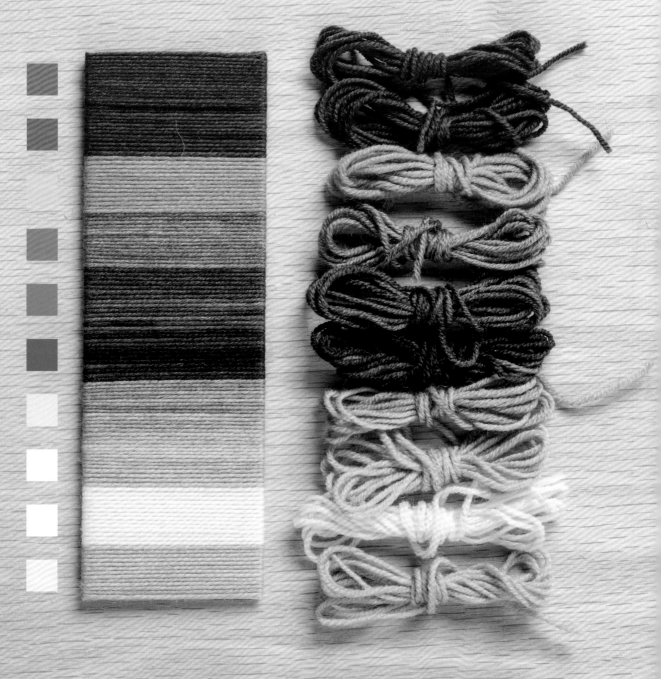

All motif swatches were knit with Neighborhood Fiber Co. Organic Studio Sock. Colors shown from top to bottom: Charles Village (hot pink), Bolton Hill (red-orange), Oliver (golden yellow), Anacostia (green), Lexington Market (dark gray), Edgewood (dark teal), Rosemont (light teal), Charles Centre (light gray), Roland Park (white), and Cross Street Market (peach).

Patterns

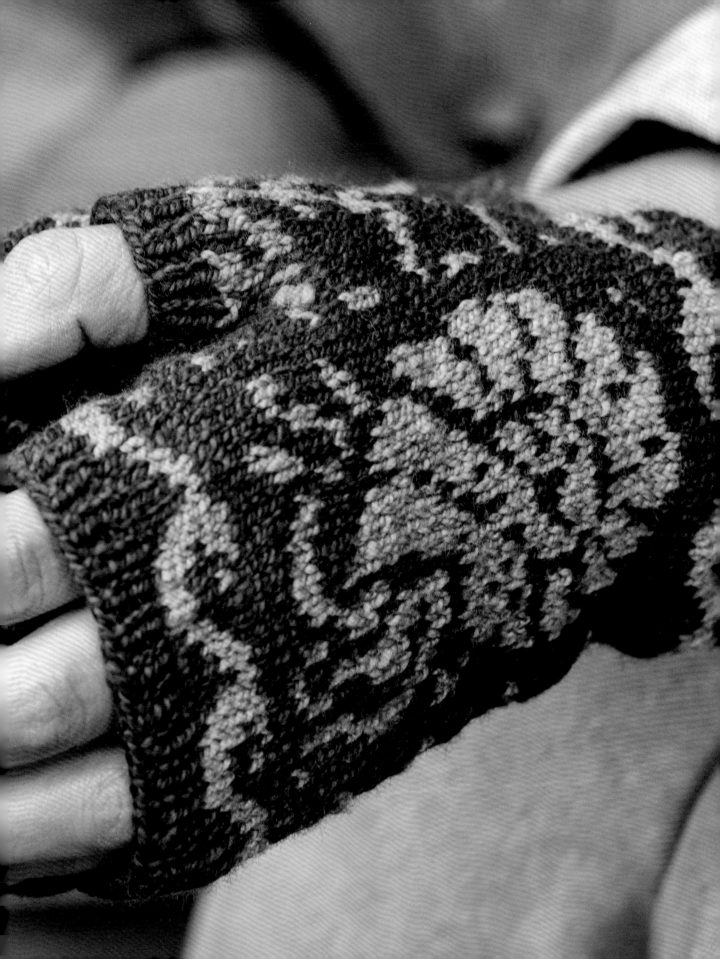

DESIGNING PROJECTS WITH COLORWORK MOTIFS

The ways in which motifs can be used in knitwear is unlimited. I've included a few patterns to help get you started and spark your imagination. For each one—a hat, a sweater, and fingerless mitts—I share technical details about the design and how I incorporated the motifs into the pattern. Understanding how each design works, you'll be able to modify my ideas to use different motifs or alter the pattern entirely to express your own creativity.

One of my goals for this book is to demonstrate how motifs can be combined and modified. The three projects in this chapter go beyond inputting exact repeats of a chart into a hat brim or sweater yoke. Instead, parts of motifs were cut away to create shaped wedges. This allows the shape of the project to go from even rows (no increases or decreases) to dimensional rows (rows with shaping) while maintaining the colorwork.

You will see the Pavo motif (p. 52) decrease in the crown of the Domed Toque. The Trellis (p. 62) and Camissonia (p. 41) motifs were combined vertically to create hanging flowers for the Midnight Garden sweater. And Nautilus (p. 96), Smoke in the Wind (p. 49), and Trailblazer (p. 50) motifs are all used together for the back of the hand, palm, and thumb of the Nautilus Fingerless Mitts.

Combining, modifying, and shaping colorwork motifs is considered an advanced level of knitting, and may not be your goal. If that's the case, enjoy knitting the projects as they are presented. However, if you're looking to go beyond the basics to further modify the projects and practice your design skills, try swapping out the motifs. I've provided blank charts for the hat crown, sweater yoke, and mitts thumb gusset so you can use the exact same stitch counts, but fill in the charts with different motifs from the book or invent your own.

The three projects in this book provide lessons in combining and shaping colorwork motifs to create finished projects with dimension.

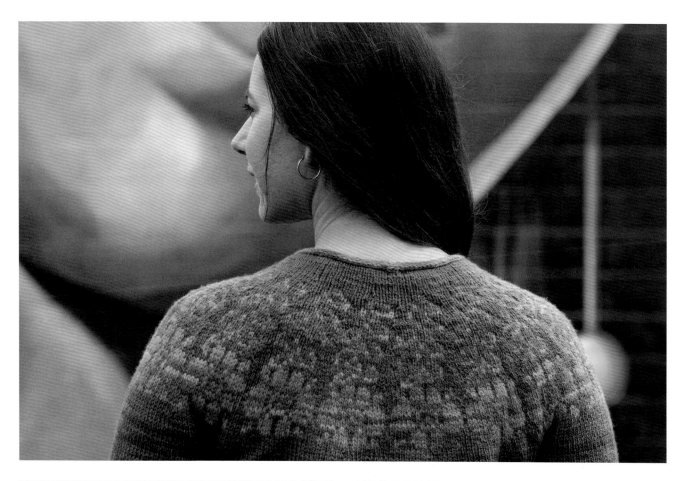

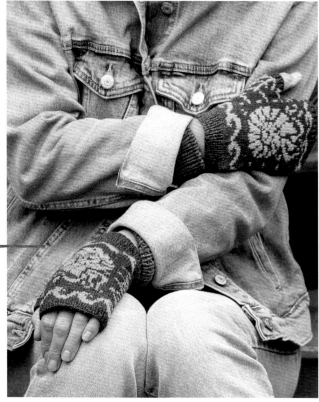

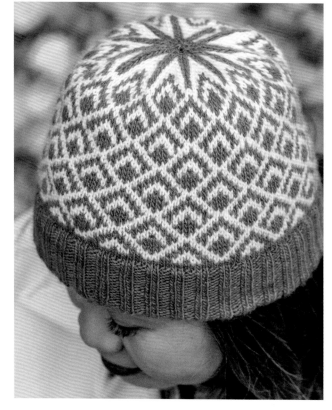

DESIGNING THE DOMED TOQUE

This hat features an allover geometric motif to create a rich surface design. It can be worked in highly contrasting bright or bold colors for a more graphic look, or choose softer neutrals for a more subtle, natural feel.

Note: You can see examples of the Pavo motif (p. 52) used in this hat throughout the Yarn Gallery (p. 14).

Crown Shaping

Decreasing for the crown of a stranded colorwork hat takes planning. Here, I chose to create wedges using decreases that brought each 12-stitch repeat to a point at the top. In order to keep things neat, I avoided decreasing at the very beginning or very end of the repeat, which is why there is a plain stitch at the beginning and end of the repeat before and after the decreases. Note: If you choose to work decreases directly next to each other, you may find that the space between them looks a little sloppy and stretched out.

To create the wedge, I use paired decreases. That means that the decrease at the beginning of the motif leans to the left and the decrease at the end leans to the right—they lean in toward each other. When they meet in the middle, you can use your preferred double-decrease method. I liked the look of it and used it in my final two decrease rounds.

The Pavo motif has a nested diamond shape that required repeating a portion of the chart to resolve. So, the first seven rounds of the crown shaping chart do not have any shaping. As you experiment with other motifs, keep in mind where you are vertically in your allover pattern. If needed, add partial repeats of your motif before beginning the crown shaping.

With the bold diamond motif, I wanted the wedge centered on the top point of the diamond. To achieve this, I used one unpaired decrease (seen in Round 8 of the chart). This also took my repeat-stitch count from an even number to an odd number, which means that when all rounds are complete, the repeat will have one final stitch.

Design Your Own

Using the blank chart provided and a repeat of 12 stitches, fill in the chart as you would a coloring book. If your pattern repeat is greater or less than twelve, you can make your own chart using graph paper. Start with the number of stitches in your repeat and follow the general shape of the wedge shown, decreasing every other round.

TIP: Decrease Stitch Color
I recommend making the stitch with the decrease symbol the same color as the stitch below it in order to keep smooth transitions in your pattern.

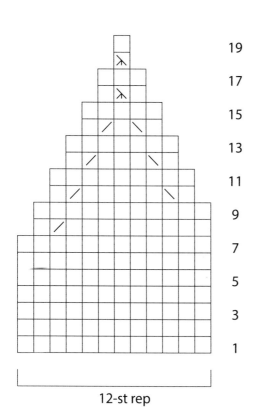

19
17
15
13
11
9
7
5
3
1

12-st rep

Domed Toque, Crown Shaping

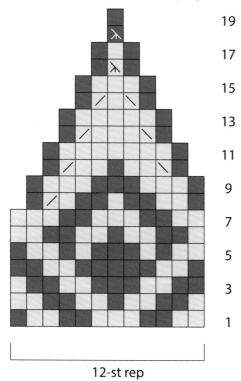

19
17
15
13
11
9
7
5
3
1

12-st rep

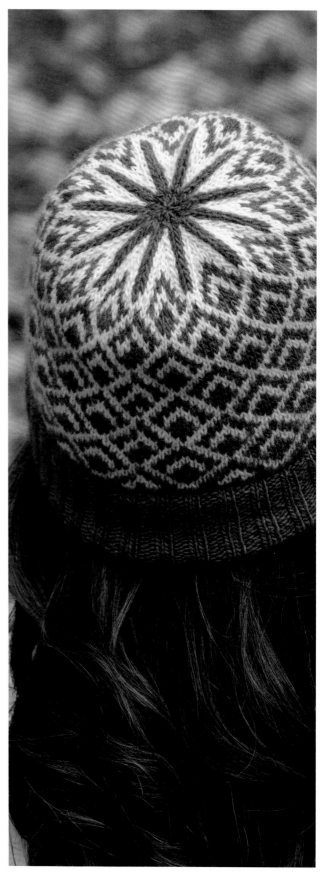

DESIGNING THE NAUTILUS FINGERLESS MITTS

Fingerless mitts are a fantastic canvas for medium-sized colorwork motifs. For these, I chose one feature motif, Nautilus (p. 96), for the main event on the back of the hand, and a smaller-repeat motif, Smoke in the Wind (p. 49), to adorn the palm. To give it that extra "underwater" feel, I edged the mitts with the wavy Crash motif (p. 47) and used a modified version of the Trailblazer motif (p. 50) for a fish bone vibe on the thumb gussets.

TIP: Variegated Yarns & Colorwork
The key to using a variegated with a solid for colorwork is to make sure that all of the colors in the variegated yarn are a good contrast with the solid. Avoid variegated yarns that have very light and very dark sections in the same skein.

Combining Motifs

When combining multiple motifs into a single pattern, stitch count is vital to a clean, cohesive finished look. The challenge with the Nautilus Fingerless Mitts was to make four different repeat stitch counts work seamlessly—10-stitch, 22-stitch, and 31-stitch charts were used.

The Crash motif wraps the wrists and fingers. It's a motif with a 10-stitch pattern repeat. Because the waves are continuous, one repeat connecting smoothly with the next, the stitch count must be exactly divisible by 10.

The hands of the mitts have a Nautilus motif on the back, repeats of a modified Smoke in the Wind motif around the rest of the hand, and a Trailblazer motif shaped into a wedge for the gusset. It's important to make sure your gusset isn't right next to the motif that you want to be featured on the back of the hand. Because of the way hands are shaped, anything right next to the gusset will look as if it's close to the thumb rather than centered on the back of the hand.

One benefit of having a large, central motif for the back of the hands is that it's not necessary to use full repeats for the smaller palm motif. Determine how many stitches you need for the hand circumference, subtract the stitches used in the larger motif, and allot the remaining stitches to the smaller motif. If the repeat isn't exact, place the same number of stitches before and after the larger motif. It's fine to use partial motifs, although I suggest making them symmetrical.

Another detail to keep in mind when choosing a chart for the palms and gussets is that the colorwork must be worked every round without plain-round breaks in order to combine with the Nautilus chart, which has colorwork every round. Single-color rounds would create very long floats across more than half of the mitt, which is impractical.

The original Smoke in the Wind chart has a single-color round before working eight rounds of colorwork. To make the motif work for these mitts, I omitted that plain round. This resulted in a slightly different-looking motif, which I anticipated and quite like.

Design Your Own

To design your own fingerless mitts, try picking a medium-sized motif, such as an animal or flower, for the back of the hand and a smaller pattern for the palm. Use the blank chart provided to plan for your thumb gusset.

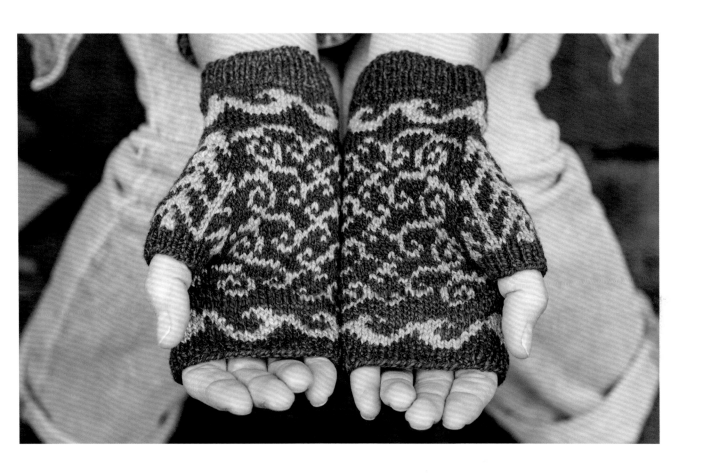

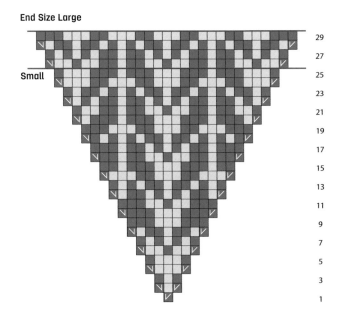

End Size Large

Small

29
27
25
23
21
19
17
15
13
11
9
7
5
3
1

End Size Large

Small

29
27
25
23
21
19
17
15
13
11
9
7
5
3
1

DESIGNING THE MIDNIGHT GARDEN PULLOVER

The yoke of a sweater is a wonderful canvas for playing with colorwork. Each style, whether raglan, circular, or otherwise, requires a unique approach to achieve the final result. My preferred sweater style for colorwork is the circular yoke. The wedges used to shape the circular yoke lend themselves well to combining motifs.

Classic Fair Isle colorwork sweaters are most often seen with circular shaping using small motifs, as opposed to raglan shaping or quite large motifs. For this pullover, I chose to modify and combine the Trellis (p. 62) and Camissonia (p. 41) motifs in a more modern design that would never be mistaken for Fair Isle.

Yoke Wedges

Whether worked from the bottom up with decreases or the top down with increases, achieving the perfect wedge shape will require planning. Gauge is vital either way, informing your rates of decrease or increase. Keep that in mind if you use the blank chart provided here to design your own sweater. If your gauge is different, this rate of change may not work for you.

In order to achieve the wedge shape of the Midnight Garden Pullover, I fussed with the motifs. I began with Trellis, starting out with just one leaf, and then repeating the motif with increasing space between the repeats. I also chose to make the leaf closest to the flower a bit daintier to fit in better. The Camissonia flowers aren't modified, except to add an increase at the very beginning to get the repeat to the necessary stitch count.

Looking at the shape of the wedge, you'll see that it isn't perfectly symmetrical and the increases don't happen exactly evenly. Circular yokes are flexible. They allow you to play with stitch count to achieve your desired pattern. For a top-down pullover, as long as you have the required stitch count to achieve your desired neck circumference, bust circumference, sleeve circumference, and yoke depth while maintaining an even rate of increase, your yoke will work out fine. However, avoid working several increase rows followed by several plain rows. This can cause funneling.

Design Your Own

Enjoy designing your own top-down circular yoke pullover with the chart provided. To further modify the design, try adding colorwork at the cuffs or at the hem. You can also try a different neckline treatment, such as 1×1 ribbing for a crew neck.

TIP: To Skip Swatching
Swatching is a vital part of the process of finding motifs that work together and designs that feel right. However, if the thought of swatching drains your creativity and motivation, try knitting a hat or mitts in your desired motif. It's not as efficient as swatching, but it's fun, less commitment, and if it doesn't fit you, it might fit someone else!

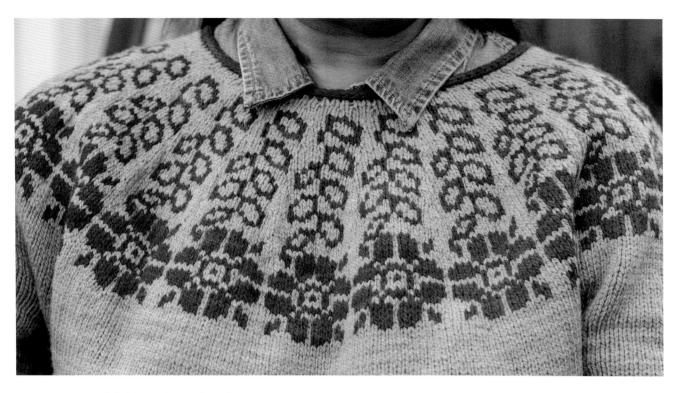

Midnight Garden Yoke Chart

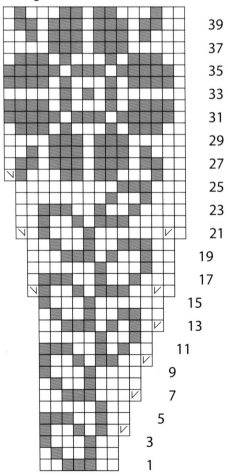

39
37
35
33
31
29
27
25
23
21
19
17
15
13
11
9
7
5
3
1

39
37
35
33
31
29
27
25
23
21
19
17
15
13
11
9
7
5
3
1

DOMED TOQUE

This graphic, bold toque is designed to help you practice your colorwork and experience shaping in pattern. A marvelous architectural dome is created with crown shaping.

SIZES & FINISHED MEASUREMENTS

Sizes
A (B, C, D, E)
Baby (Child, Adult Small, Adult Medium, Adult Large)

Measurements
Hat circumference:
15½ (17, 18¾, 20½, 22¼)"
39.5 (43, 47.5, 52, 56.5) cm
Hat length, top of crown to bottom of brim:
7½ (7½, 7¾, 8¼, 8¾)"
19 (19, 19.5, 21, 22) cm

Shown here in size 20½" (52 cm).

YARN

Fingering-weight yarn in 2 colors.
Main Color (MC)
117 (129, 142, 155, 168) yd
107 (118, 130, 142, 154) m
Contrast Color (CC)
53 (58, 64, 70, 76) yd
48 (53, 59, 64, 69) m

Shown here in Neighborhood Fiber Co. Organic Rustic Fingering (100% organic Merino wool; 475 yd [434 m]/4 oz [114 g]):
Main Color: Lexington Market, 1 skein;
Contrast Color: Roland Park, 1 skein.

NEEDLES

U.S. size 3 (3.25 mm) and U.S. size 5 (3.75 mm): 16" (40 cm) circular needle and set of double-pointed needles, or preferred small-circumference needle such as a long circular needle for Magic Loop method.

GAUGE

28 stitches and 32 rounds = 4" (10 cm) in colorwork pattern using larger needle.
Adjust needle size if necessary to obtain correct gauge.

NOTIONS

Markers (m), tapestry needle, waste yarn, spare 16" (40 cm) circular needle same size or smaller than the smaller needle, and size D (3.25 mm) crochet hook.

NOTES

- Hat is worked brim-up with a provisional cast-on. Brim is worked to twice the desired length, then folded in half and the provisional stitches knit together with the live stitches for a doubled brim.

- This toque is designed to have a round beanie shape. If you prefer a slouchier shape, work an additional repeat of the 10-round Main Chart before beginning the Crown Chart.

- Charts are provided for two variations: Light MC with Dark CC, and Dark MC with Light CC. Choose the variation that best suits your color palette.

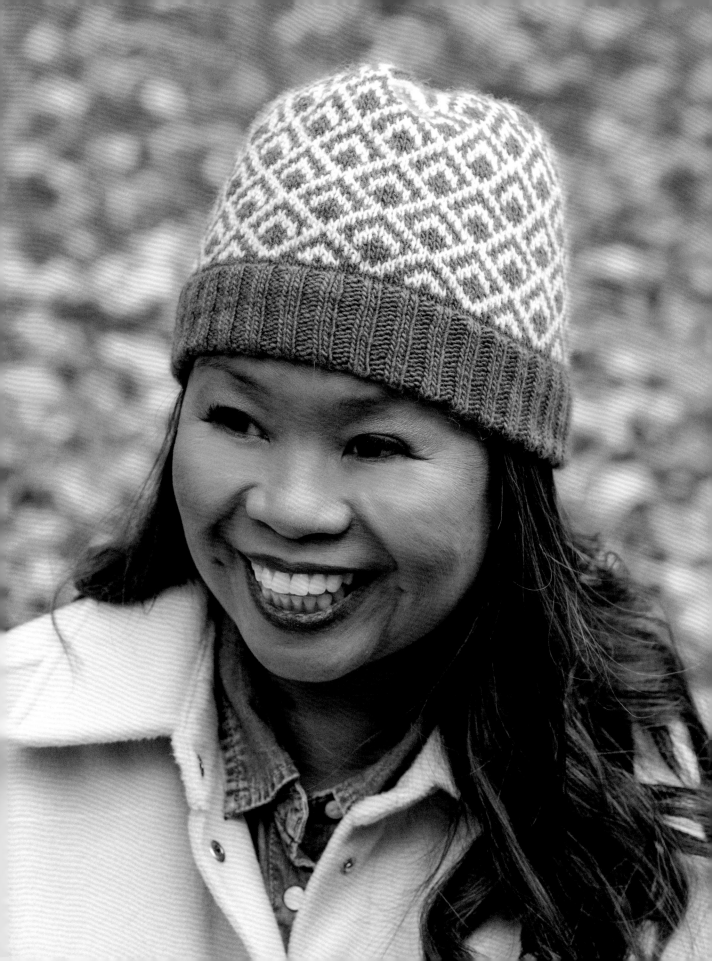

HAT INSTRUCTIONS

BRIM

With smaller 16" (40 cm) circular needle, crochet hook, and waste yarn, and using Crochet Provisional Cast-on method (see **Techniques Glossary**), CO 108 (120, 132, 144, 156).

Join Main Color. Knit 1 row.

Place m and join for working in the round.

Round 1: *K2, p2; repeat from * to end.

Repeat Round 1 until Brim measures 2 (2, 2½, 3½, 4½)" (5 [5, 6.5, 9, 11.5] cm) from cast-on edge.

Carefully remove waste yarn from cast-on edge and place stitches on spare 16" (40 cm) circular needle. Fold Brim in half so that live stitches are in front of provisional stitches and Brim is half the worked length.

Joining Round: *Knit 1 stitch from live stitches together with 1 stitch from provisional stitches; repeat from * to end.

Brim is now joined and doubled.

Knit 1 round.

COLORWORK SECTION

Switch to larger needle if necessary to maintain gauge over colorwork. Join Contrast Color and work Rounds 1–10 of Main Chart three times. The 12-stitch repeat is worked 9 (10, 11, 12, 13) times around.

CROWN

Work Rounds 1–19 of Crown Chart, switching to double-pointed needles, long circular needle, or other small-circumference method when circumference is too small to work on 16" (40 cm) circular needle.

Stitch count—9 (10, 11, 12, 13) stitches remain after completing Crown Chart.

Sizes A (-, C, -, E) Only
Final Decrease Round: K1, *ssk; repeat from * to end.

Sizes - (B, -, D, -) Only
Final Decrease Round: *Ssk; repeat from * to end.

All sizes resume
Stitch count—5 (5, 6, 6, 7) stitches remain.

Cut both yarns, leaving 6" (15 cm) tails. Thread Main Color tail onto a tapestry needle and draw through all remaining stitches. Pull tight like a drawstring. For a secure finish, draw yarn through stitches one more time, then bring through the center of the crown to the inside. Thread Contrast Color tail onto a tapestry needle and bring it to the inside as well.

FINISHING

Weave in ends using duplicate stitch on the wrong side.

Wet block

Hand wash hat in room temperature water and gentle soap or wool wash. Rinse by swishing gently in clean water, then squeeze out excess moisture in a towel. Lay flat or dry on a hat form.

Main Chart, Light Main Color

9
7
5
3
1

12-st rep

Main Chart, Dark Main Color

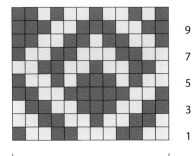

9
7
5
3
1

12-st rep

Crown Chart, Light Main Color

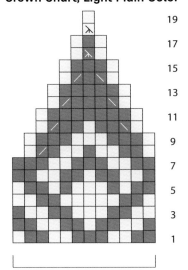

19
17
15
13
11
9
7
5
3
1

12-st to 1-st rep

Crown Chart, Dark Main Color

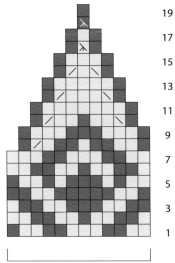

19
17
15
13
11
9
7
5
3
1

12-st to 1-st rep

 knit Main Color

 knit Contrast Color

 k2tog Contrast Color

 ssk Contrast Color

 sk2p Contrast Color

sk2p Main Color

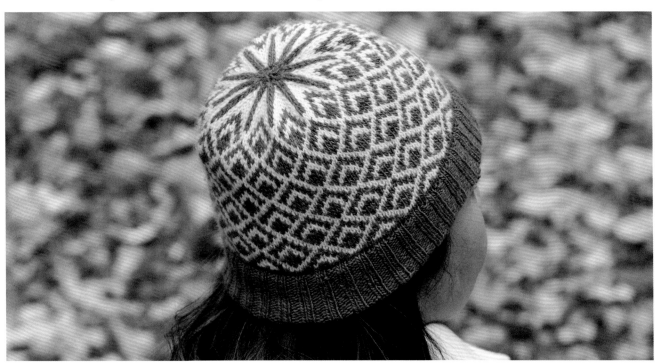

NAUTILUS FINGERLESS MITTS

Take a trip to the watery depths with nautiluses in the waves. These small mitts will have a big impact with mesmerizing underwater colorwork motifs.

SIZES & FINISHED MEASUREMENTS

Sizes
A (B)
Adult Small (Adult Large)

Measurements
Hand circumference:
7 (8¼)"
18 (21) cm

Shown here in size 7" (18 cm).

YARN

Fingering- or sport-weight yarn in 2 colors.
Main Color (MC)
150 (176) yd
137 (161) m
Contrast Color (CC)
68 (80) yd
62 (73) m

Shown here in Spincycle Yarns Dyed in the Wool (100% superwash American wool; 200 yd [183 m]): Main Color: Nightwatch, 1 skein. Spincycle Yarns Nocturne (100% Merino wool; 200 yd [183 m]): Contrast Color: Pick Your Poison, 1 skein.

NEEDLES

Ribbing and one-color Stockinette stitch: U.S. size 2 (2.75 mm) set of double-pointed needles, or preferred small-circumference needle such as a long circular needle for Magic Loop method.

Colorwork: U.S. size 4 (3.5 mm) set of double-pointed needles, or preferred small-circumference needle.

GAUGE

34 stitches and 40 rounds = 4" (10 cm) in colorwork stitch pattern using larger needle. *Adjust needle size if necessary to obtain correct gauge.*

NOTIONS

Markers (m), tapestry needle, and waste yarn.

NOTES

- Mitts are worked from wrist to fingers. Thumb gusset is worked at the same time as mitt, then thumb stitches are placed on waste yarn to finish the remainder of the mitt. Thumb cuff is worked from stitches on waste yarn.

Total length: 6¾" (17 cm)

Hand circumference: 7 (8¼)" (18 [21] cm)

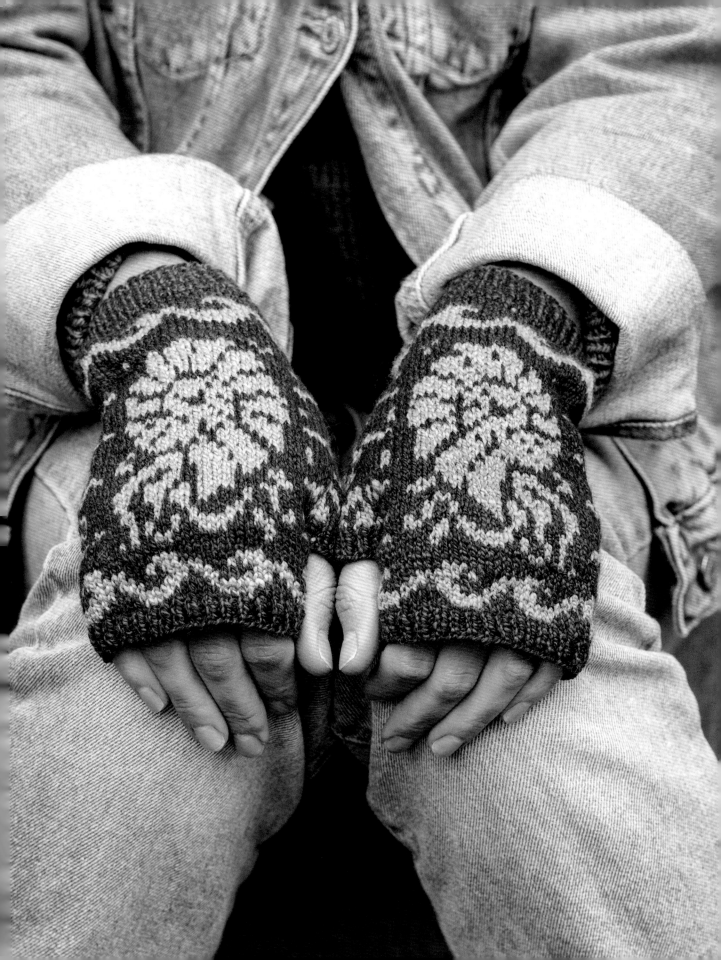

MITT INSTRUCTIONS

WRIST CUFF
With smaller needle and Main Color, CO 56 (68) stitches. Place m and join for working in the round.

Ribbing
Round 1: (K1, p1) around.

Repeat Round 1 nine more times or until Wrist Cuff measures about 1" (2.5 cm) from cast-on edge.

Increase Round: *K14 (34), M1; repeat from * to end. —4 (2) stitches increased; 60 (70) stitches total.

Knit 1 round.

COLORWORK
Note: Switch to larger needle if necessary to maintain gauge across colorwork.

Work Rounds 1–6 of Crash Right Hand chart 6 (7) times around.

Note: Switch to smaller needle if necessary to maintain gauge in plain Stockinette stitch.

With Main Color, knit 2 rounds.

GUSSET AND HAND
Note: Switch to larger needle if necessary to maintain gauge across colorwork.

Work Round 1 of Gusset chart, place m, work Round 1 of Nautilus Right Hand chart for your size—61 (71) stitches total.

Continue as established, working through Round 25 (29) of charts—85 (99) stitches total: 25 (29) for Gusset and 60 (70) for Hand.

Separate Thumb Stitches
Place 25 (29) Gusset stitches on waste yarn. Remove one marker, rejoin for working in the round, and continue working Nautilus Right Hand chart through Round 32.

Note: Switch to smaller needle if necessary to maintain gauge in plain Stockinette stitch.

With Main Color, knit 2 rounds.

Note: Switch to larger needle if necessary to maintain gauge across colorwork.

Work Rounds 1–6 of Crash Right Hand chart 6 (7) times around.

Note: Switch to smaller needle if necessary to maintain gauge in plain Stockinette stitch.

With Main Color, knit 2 rounds.

FINGER CUFF
Round 1: (K1, p1) around.
Repeat Round 1 twice more or until ribbing measures about ½" (1 cm).

Bind off all stitches in pattern.

THUMB CUFF
Place 25 (29) held stitches on smaller needles. Use only Main Color for Thumb Cuff.

Setup Round: Knit to end, pick up and knit 1 stitch at thumb crotch.

Round 1: (K1, p1) around.
Repeat Round 1 three more times or until ribbing measures about ½" (1 cm).

Bind off all stitches in pattern.

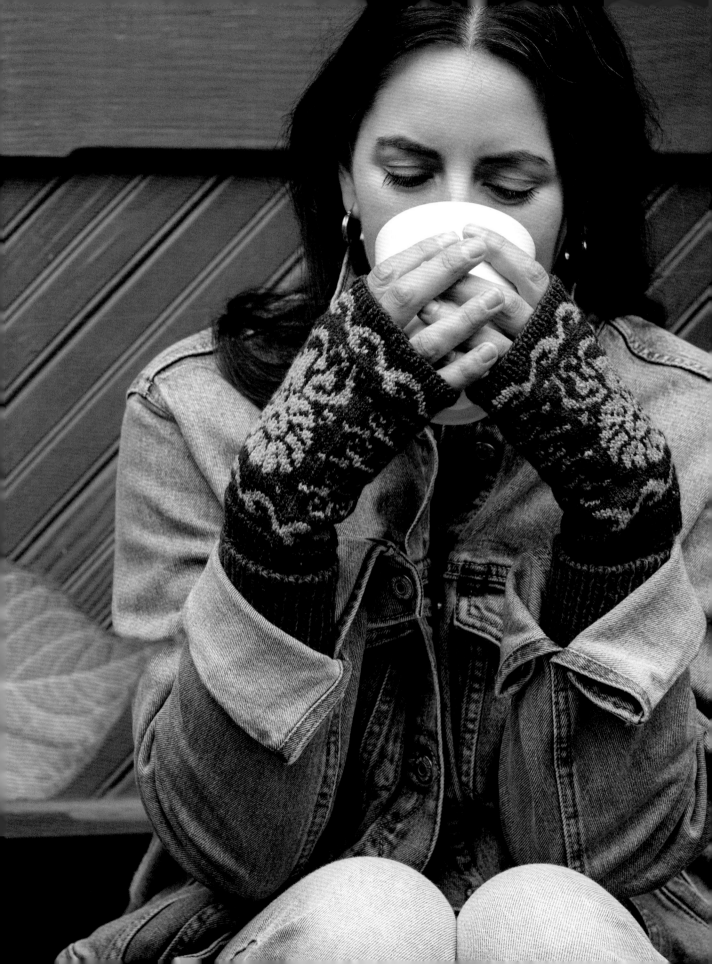

LEFT HAND

Work as for the Right Hand, using the Left Hand charts where necessary throughout.

FINISHING

Weave in ends on WS using duplicate stitch, being careful to close any gap at the thumb crotch.

Wet block

Hand wash mitts in room temperature water and gentle soap or wool wash. Rinse by swishing gently in clean water, then squeeze out excess moisture in a towel. Lay flat to dry. After the mitts are dry, use a steamer to steam out creases along the sides.

Gusset, both sizes

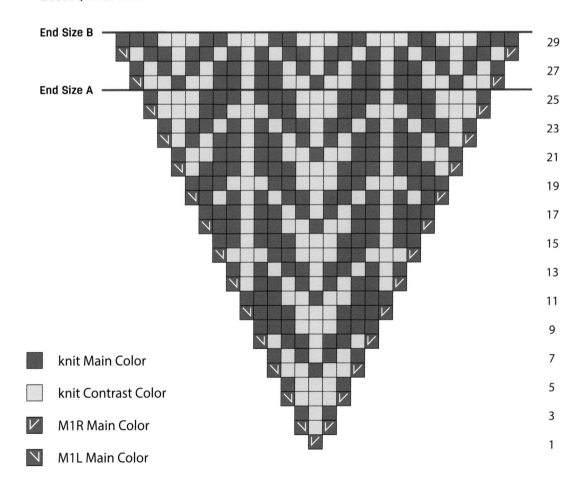

knit Main Color

knit Contrast Color

M1R Main Color

M1L Main Color

Crash Right Hand

10-st rep

Nautilus Right Hand, Size A

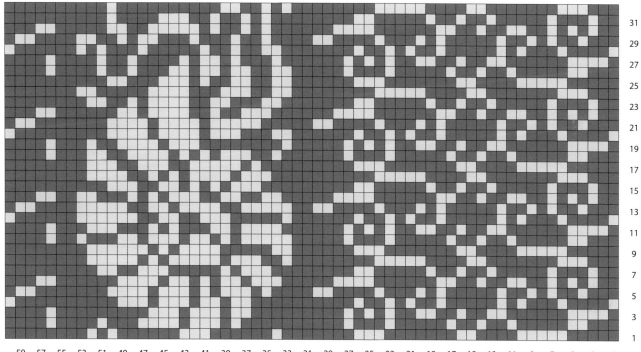

Nautilus Right Hand, Size B

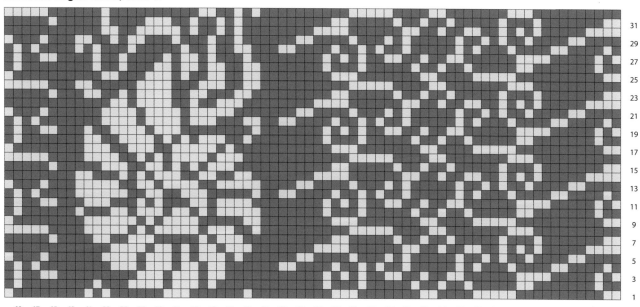

Crash Left Hand

5
3
1

■ knit Main Color
□ knit Contrast Color

10-st rep

Nautilus Left Hand, Size A

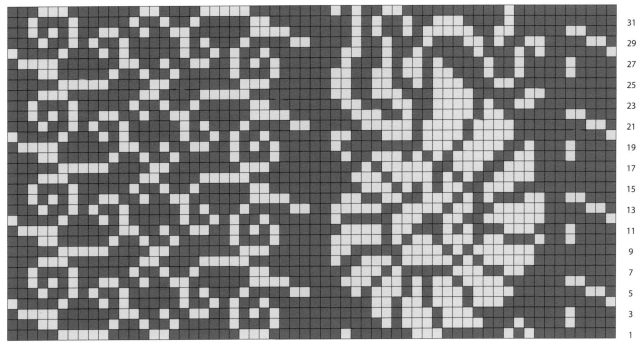

Nautilus Left Hand, Size B

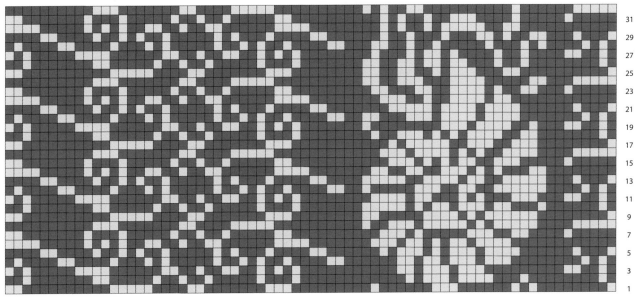

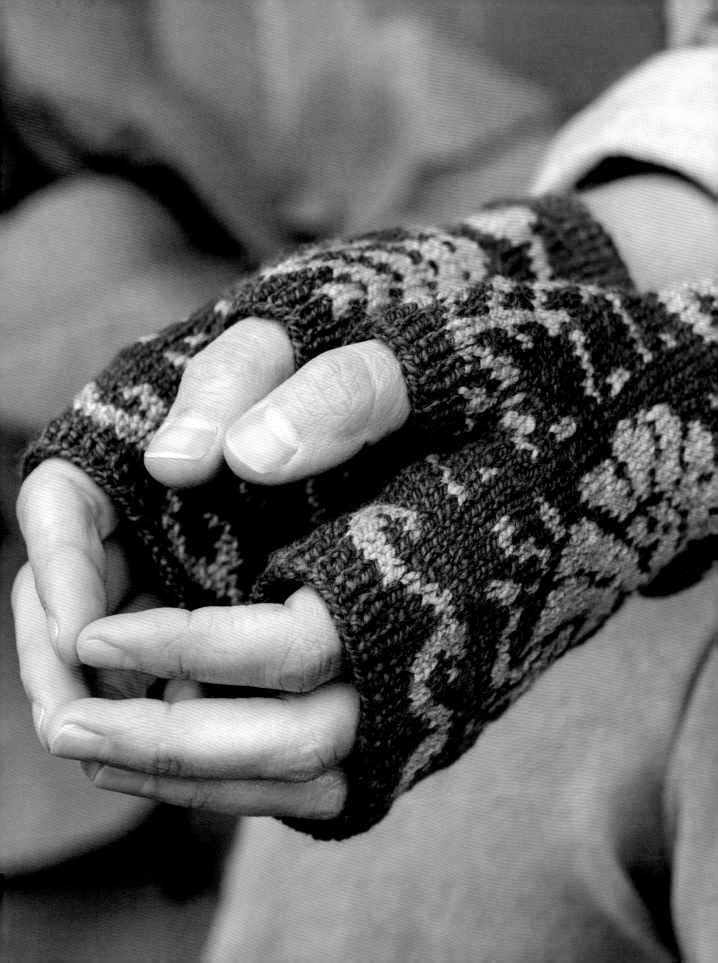

MIDNIGHT GARDEN PULLOVER

Midnight Garden is a bewitchingly striking pullover with cascading vines and florals adorning the yoke. The dramatic motif pairs with a relaxed fit, simple top-down construction, and DK-weight yarn for a marvelous, fun-to-knit project you'll love making and wearing.

SIZES & FINISHED MEASUREMENTS

Sizes
A (B, C, D, E) **[F, G, H, I]** (J, K, L, M)

Measurements
Chest circumference:
33 (36, 39, 42.25, 45) **[48, 51, 54¼, 57]** (60, 63, 66¼, 69)"
84 (91.5, 99, 107.5, 114.5) **[122, 129.5, 138, 145]** (152.5, 160, 168.5, 175.5) cm
See Midnight Garden Pullover Schematic for other key measurements.

Shown here in size A (golden colorwork) modeled with 1" (2.5 cm) negative ease, and size E (crimson colorwork) modeled with 3½" (9 cm) positive ease.

YARN

DK-weight yarn in 2 colors.
Main Color (MC)
1021 (1102, 1188, 1210, 1227) **[1302, 1348, 1454, 1572]** (1655, 1749, 1859, 1959) yd
934 (1008, 1086, 1106, 1122) **[1190, 1233, 1329, 1438]** (1513, 1599, 1699, 1791) m
Contrast Color (CC)
113 (119, 119, 132, 144) **[150, 159, 173, 187]** (194, 201, 216, 223) yd
103 (109, 109, 120, 132) **[137, 146, 158, 171]** (178, 184, 197, 204) m

Shown here in The Farmer's Daughter Pishkun (100% Montana & Wyoming Rambouillet; 255 yd [233 m]/3½ oz [100 g]): Main Color: 5 (5, 5, 5, 5) **[6, 6, 6, 7]** (7, 7, 8, 8) skeins; Contrast Color: 1 skein.

Sample Size A - Main Color: Castle Rock; Contrast Color: Werther's OG.
Sample Size E - Main Color: Elk Antler; Contrast Color: Boyland.

NEEDLES

Stockinette stitch and ribbing: U.S. size 6 (4 mm): 32" (80 cm) circular needle, 16" (40 cm) circular needle, and set double-pointed needles, or preferred small-circumference needle such as a long circular needle for Magic Loop method.
Colorwork: U.S. size 8 (5 mm): 32" (80 cm) circular needle.

GAUGE

22 stitches and 28 rounds = 4" (10 cm) in Stockinette stitch using smaller needle.
22 stitches and 26 rounds = 4" (10 cm) in colorwork stitch pattern using larger needle.
27 stitches and 32 rounds = 4" (10 cm) in ribbing using smaller needle.
Adjust needle size if necessary to obtain correct gauge.

NOTIONS

Markers (m), tapestry needle, waste yarn, and spare circular needle the same size or smaller than your Stockinette stitch gauge needle.

NOTES

- Pullover is worked top-down seamlessly in the round. Yoke is worked first with short-row shaping to raise the Back Neck, then separated for the Body and Sleeves to be worked separately. I-cord neck edging is picked up and worked after binding off.

- To make reading and following the pattern less difficult, sizes A–E appear on pages 130–135 and sizes F–M appear on pages 136–141. Be sure to follow the pattern for your size on the appropriate pages.

Midnight Garden Pullover Schematic

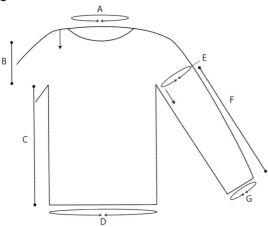

Measurements in Inches

A: 18¼ (18¼, 18¼, 18¼, 18¼) **[18¼, 19, 19, 19]** (19, 19, 20, 20)"

B, Front Yoke Depth: 7¾ (8, 8¼, 8½, 8¾) **[9, 9¼, 9½, 9¾]** (10, 10¼, 10½, 10¾)"

C: 14"

D: 33 (36, 39, 42.25, 45) **[48, 51, 54¼, 57]** (60, 63, 66¼, 69)"

E: 12 (12½, 13½, 15¾, 17) **[17¾, 18¼, 19, 21]** (21½, 22¼, 22½, 23)"

F: 18"

G: 8 (8, 8, 8¼, 8¼) **[8¾, 8¾, 9, 9]** (9½, 9¾, 9¾, 10¼)"

Measurements in Centimeters

A: 46.5 (46.5, 46.5, 46.5, 46.5) **[46.5, 48.5, 48.5, 48.5]** (48.5, 48.5, 51, 51) cm

B, Front Yoke Depth: 19.5 (20.5, 21, 21.5, 22) **[23, 23.5, 24, 25]** (25.5, 26, 26.5, 27.5) cm

C: 35.5 cm

D: 84 (91.5, 99, 107.5, 114.5) **[122, 129.5, 138, 145]** (152.5, 160, 168.5, 175.5) cm

E: 30.5 (32, 34.5, 40, 43) **[45, 46.5, 48.5, 53.5]** (54.5, 56.5, 57, 58.5) cm

F: 45.5 cm

G: 20.5 (20.5, 20.5, 21, 21) **[22, 22, 23, 23]** (24, 25, 25, 26) cm

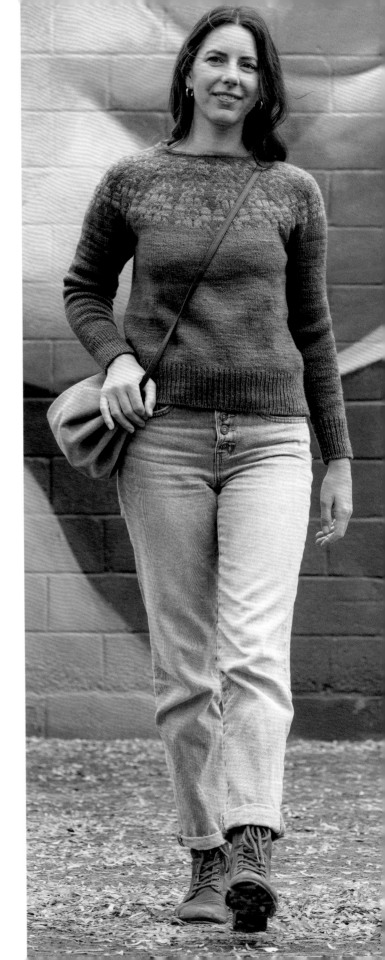

INSTRUCTIONS FOR SIZES A (B, C, D, E)

YOKE

With smaller 16" (40 cm) needle and Main Color, CO 100 stitches. Place marker and join for working in the round. Beginning of round is at Center Back.

Knit 1 round.

Shape Back Neck

Note: Short-rows are used to add length to the Back Neck, allowing the neckline to be lower in the front than in the back and giving a more comfortable front neckline.

Short-row 1: Knit 33, w&t.
Short-row 2 (WS): Purl to marker, slip marker, purl 33, w&t.
Short-row 3: Knit to marker, slip marker, knit 29, w&t.
Short-row 4: Purl to marker, slip marker, purl 29, w&t.
Short-row 5: Knit to marker, slip marker, knit 25, w&t.
Short-row 6: Purl to marker, slip marker, purl 25, w&t.
Short-row 7: Knit to marker, slip marker, knit 21, w&t.
Short-row 8: Purl to marker, slip marker, purl 21, w&t.
Finish short-rows as follows:
Knit to marker. Slip marker and knit to end, working wrapped stitches together with their wraps when you come to them.

Shape Yoke

Note: Switch to longer, smaller circular needle when working on 16" (40 cm) needle is no longer comfortable.

Increase 12 (19, 19, 33, 24) stitches evenly in next round as follows:
Increase Round: Knit 4 (2, 2, 1, 2), [M1, k9 (5, 5, 3, 5)] 2 (7, 7, 16, 2) times, [M1, k8 (6, 6, 4, 4)] 7 (5, 5, 1, 19) times, [M1, k9 (5, 5, 3, 5)] 2 (6, 6, 15, 2) times, M1, k4 (3, 3, 2, 2).

Stitch count—112 (119, 119, 133, 124) stitches.

Size - (-, -, -, E) Only

Increase 23 stitches evenly in the next round as follows:

Increase Round: K2, [M1, k5] seven times, [M1, k6] nine times, [M1, k5] six times, M1, k3.

All sizes resume.

Stitch count—112 (119, 119, 133, 147) stitches.

COLORWORK YOKE SECTION

Note: Switch to larger needle for colorwork rounds if necessary to maintain gauge. Two versions of charts are given, a light Main Color chart and a dark Main Color chart. Use the color scheme that best matches your project.

With Main Color and Contrast Color, work Rounds 1–40 of colorwork Chart A. Pattern is worked 16 (17, 17, 19, 21) times around yoke.

Stitch count—256 (272, 272, 304, 336) stitches.

After completing all chart rounds, cut Contrast Color, leaving a 6" (15 cm) tail. Switch back to smaller, longer needle if necessary to maintain gauge.

Knit 2 rounds with Main Color.

Sizes A (B, -, D, E) Only

Increase 14 (20, -, 21, 19) stitches evenly in round as follows:
Increase Round: Knit 9 (6, -, 7, 8), [M1, k19 (14, -, 15, 17)] 2 (6, -, 5, 3) times, [M1, k18 (13, -, 14, 18)] 9 (7, -, 10, 13) times, [M1, k19 (14, -, 15, 17)] 2 (6, -, 5, 2) times, M1, k9 (7, -, 7, 9).

Size - (-, C, -, -) Only

Increase Round 1: Knit 6, [M1, k13] twenty times, M1, k6.
Increase Round 2: Knit 6, [M1, k14] twenty times, M1, k7.

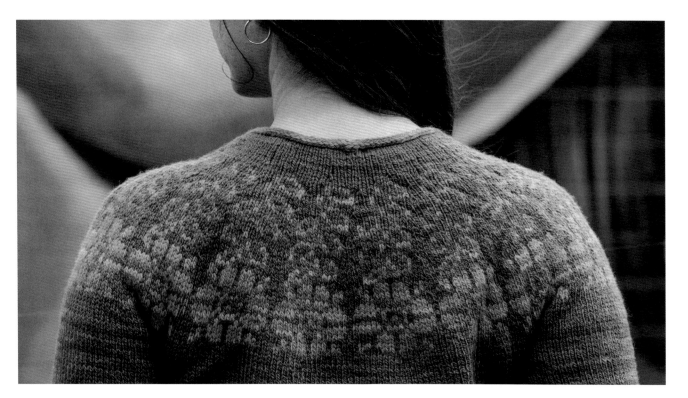

Chart A, Dark Main Color

Chart A, Light Main Color

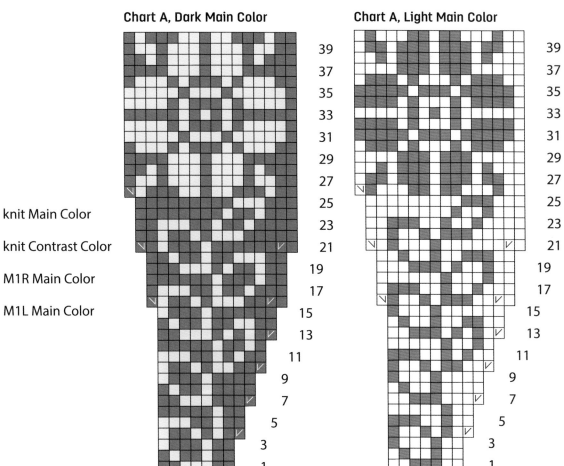

knit Main Color

knit Contrast Color

M1R Main Color

M1L Main Color

Sizes - (-, -, D, E) Only

Increase - (-, -, 21, 19) stitches evenly in next round as follows:

Increase Round: Knit - (-, -, 7, 9), [M1, k- (-, -, 16, 18)] - (-, -, 5, 3) times, [M1, k- (-, -, 15, 19)] - (-, -, 10, 13) times, [M1, k- (-, -, 16, 18)] - (-, -, 5, 2) times, M1, k- (-, -, 8, 9).

Stitch count—270 (292, 314, 346, 374) stitches.

All sizes resume.

Knit 6 (7, 8, 10, 11) more rounds or until Yoke depth measures about 7¾ (8, 8¼, 8½, 8¾)" (19.5 [20.5, 21, 21.5, 22] cm) along Center Front measured from CO, or to desired Yoke depth. Note: Center Front is directly opposite the BOR marker, which indicates the Center Back. It's important to measure here instead of at the BOR marker to avoid counting the short-row shaping depth that increases the depth at the Back Neck.

Fit Tip
For a perfect fit, try on before working the plain Stockinette section to determine how many more rounds to work. The Yoke should end just below your underarm to get the look shown. After working a few inches of the Body, try on again to be sure the underarm placement is comfortable and achieves your desired look. For a more accurate result, steam block your work-in-progress before trying on or checking gauge.

DIVIDE FOR BODY & SLEEVES

Dividing Round: Knit 40 (44, 48, 51, 55) stitches for right half of Back (as worn).

Place next 55 (58, 62, 72, 78) stitches on waste yarn for Right Sleeve.

CO 11 (11, 12, 15, 15) stitches using backward loop method for Underarm (see **Techniques Glossary**).

Knit 80 (88, 95, 101, 109) stitches for Front.

Place next 55 (58, 62, 72, 78) stitches on waste yarn for Left Sleeve.

CO 11 (11, 12, 15, 15) stitches using backward loop method for Underarm.

Knit 40 (44, 47, 50, 54) stitches for Left Back.

Stitch count—182 (198, 214, 232, 248) stitches for Body.

BODY

Work in Stockinette stitch (knit every round) until Body measures 11" (28 cm) from underarm, or 77 rounds at pattern gauge.

Hem

Ribbing Round: (K1, p1) to end.
Repeat ribbing round until Ribbing measures 3" (7.5 cm), or 24 rounds at pattern gauge.

Bind off all stitches using Tubular Bind-off method (see **Techniques Glossary**).

SLEEVES (MAKE 2)

Place live Sleeve stitches on smaller needle for small-circumference knitting. Join Main Color yarn and knit to end. Pick up and knit 6 (6, 7, 8, 8) underarm stitches (one extra between sleeve stitches and cast-on underarm stitches to prevent a hole from forming, and one in each cast-on stitch), place marker for beginning of round, pick up and knit 7 (7, 7, 9, 9) underarm stitches (one in each cast-on stitch, and one extra between sleeve stitches and cast-on underarm stitches), knit to end of round.

Stitch count—68 (71, 76, 89, 95) stitches.

In the next round, decrease away the extra stitches that were picked up between sleeve stitches and cast-on underarm stitches as follows:
Next Round (decrease): Knit 6 (6, 6, 8, 8) stitches, k2tog, knit to 7 (7, 8, 9, 9) stitches before marker, k2tog, knit to end.

Stitch count—66 (69, 74, 87, 93) stitches remain.

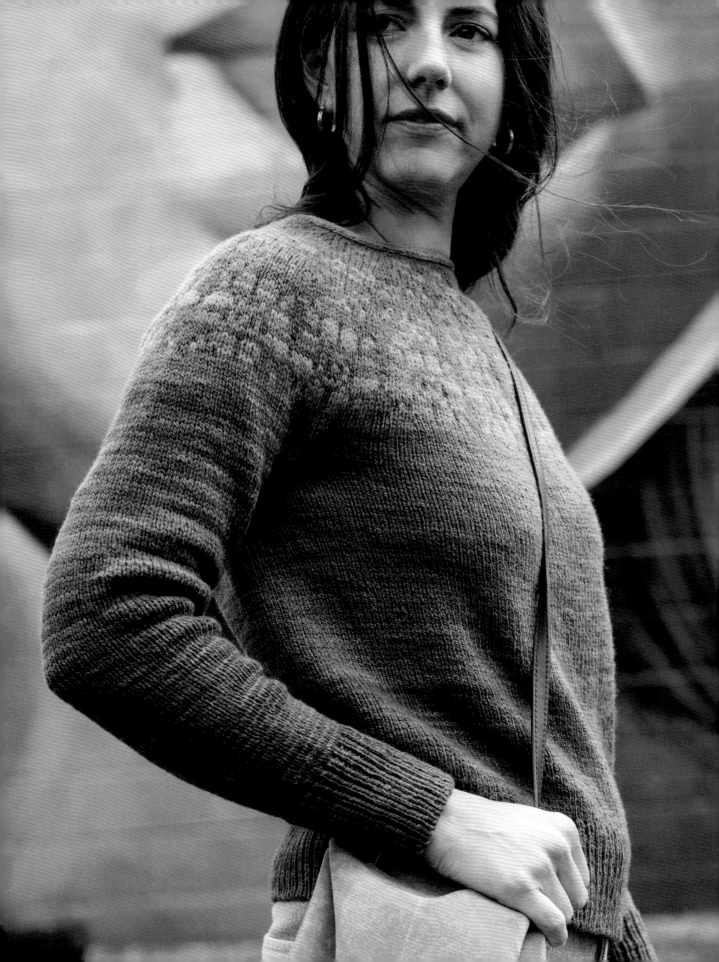

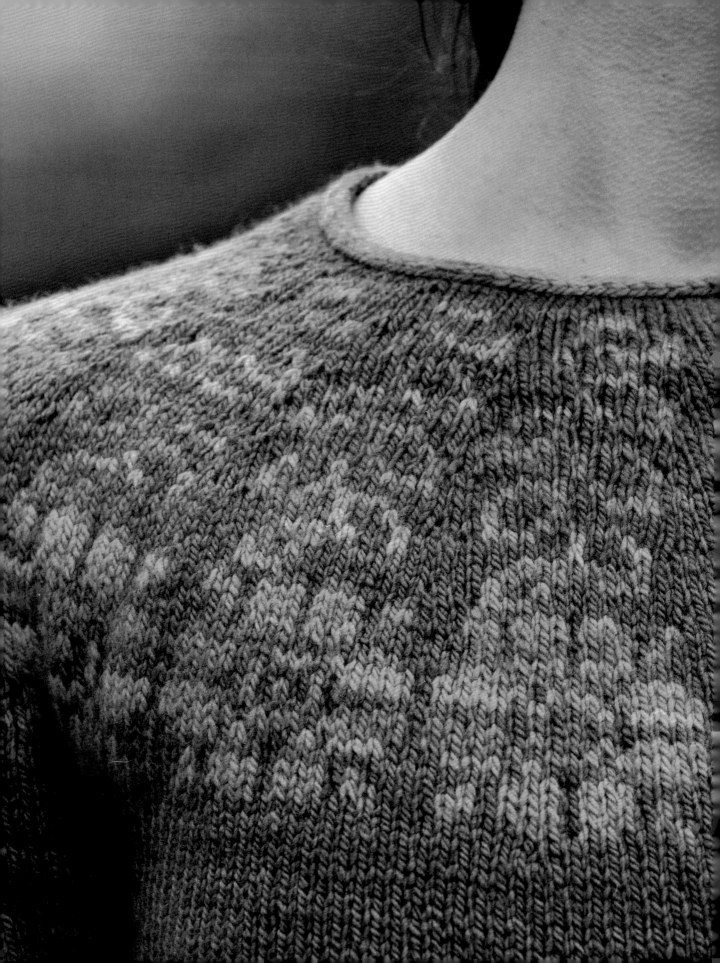

Knit 20 (20, 18, 18, 16) rounds.

Decrease on next round and every 8th (8th, 6th, 6th, 4th) round 7 (4, 10, 0, 20) times, then every 6th (6th, 4th, 4th, 2nd) round 3 (7, 4, 19, 2) times as follows:
Decrease Round: Knit 1, ssk, knit to last 2 stitches, k2tog— 2 stitches decreased.

Stitch count—44 (45, 44, 47, 47) stitches remain.

Knit 8 (8, 8, 8, 2) more rounds, or until Sleeve measures 15" (38 cm) from Underarm.

Decrease 0 (1, 0, 1, 1) stitch(es) in the next round as follows:
Note: If the number for your size is 0, omit the decrease round.
Decrease Round: Knit 1, ssk, knit to end.

Stitch count—44 (44, 44, 46, 46) stitches remain.

CUFF
Work 1×1 ribbing for Cuff as follows:
Ribbing Round: (K1, p1) to end.
Repeat ribbing round 23 more times or until cuff measures 3" (7.5 cm).

Work Tubular Bind-off as for Body.

I-CORD COLLAR
With smaller 16" (40 cm) needle and Contrast Color, pick up and knit 100 stitches around Neckline, beginning at Center Back where cast-on tail is. Note: That's one picked-up stitch for every cast-on stitch.

Bind off all stitches using I-cord Bind-off method (see **Techniques Glossary**).

FINISHING
Weave in ends on WS using duplicate stitch.

Wet block
Hand wash sweater in room temperature water and gentle soap or wool wash. Rinse by swishing gently in clean water, then squeeze out excess moisture in a towel. Lay flat to dry. After the sweater is dry, use a steamer to steam out creases along the sides of Sleeves and Body.

INSTRUCTIONS FOR SIZES [F, G, H, I] (J, K, L, M)

YOKE

With smaller 16" (40 cm) needle and Main Color, CO [100, 104, 104, 104] (104, 104, 110, 110) stitches. Place marker and join for working in the round. Beginning of round is at Center Back.

Knit 1 round.

Shape Back Neck

Note: Short-rows are used to add length to the Back Neck, allowing the neckline to be lower in the front than in the back and giving a more comfortable front neckline.

Short-row 1: Knit [33, 35, 35, 35] (35, 35, 37, 37), w&t.

Short-row 2 (WS): Purl to marker, slip marker, purl [33, 35, 35, 35] (35, 35, 37, 37), w&t.

Short-row 3: Knit to marker, slip marker, knit [29, 31, 31, 31] (31, 31, 33, 33), w&t.

Short-row 4: Purl to marker, slip marker, purl [29, 31, 31, 31] (31, 31, 33, 33), w&t.

Short-row 5: Knit to marker, slip marker, knit [25, 27, 27, 27] (27, 27, 29, 29), w&t.

Short-row 6: Purl to marker, slip marker, purl [25, 27, 27, 27] (27, 27, 29, 29), w&t.

Short-row 7: Knit to marker, slip marker, knit [21, 23, 23, 23] (23, 23, 25, 25), w&t.

Short-row 8: Purl to marker, slip marker, purl [21, 23, 23, 23] (23, 23, 25, 25), w&t.

Finish short-rows as follows:

Knit to marker. Slip marker and knit to end, working wrapped stitches together with their wraps when you come to them.

Shape Yoke

Note: Switch to longer, smaller circular needle when working on 16" (40 cm) needle is no longer comfortable.

Increase [28, 22, 28, 36] (40, 42, 46, 50) stitches evenly in next round as follows:

Increase Round: Knit [1, 2, 1, 1] (1, 1, 1, 1), [M1, knit [4, 5, 4, 3] (3, 3, 3, 3)] [8, 8, 10, 16] (12, 10, 9, 5) times, [M1, knit [3, 4, 3, 2] (2, 2, 2, 2)] [11, 5, 7, 3] (15, 21, 27, 39) times, [M1, knit [4, 5, 4, 3] (3, 3, 3, 3)] [8, 8, 10, 16] (12, 10, 9, 5) times, M1, knit [2, 2, 2, 1] (1, 1, 1, 1).

Stitch count—[128, 126, 132, 140] (144, 146, 156, 160) stitches present.

Sizes [F, -, H, -] (J, K, L, M) Only

Increase [26, -, 29, -] (38, 43, 47, 50) stitches evenly in the next round as follows:

Increase Round: Knit [2, -, 2, -] (1, 1, 1, 1), [M1, knit [5, -, 5, -] (4, 3, 3, 4)] [12, -, 8, -] (15, 13, 16, 5) times, [M1, knit [4, -, 4, -] (3, 4, 4, 3)] [1, -, 12, -] (7, 17, 15, 39) time(s), [M1, knit [5, -, 5, -] (4, 3, 3, 4)] [12, -, 8, -] (15, 12, 15, 5) times, M1, knit [2, -, 2, -] (2, 2, 2, 2).

Sizes [-, G, -, I] (-, -, -, -) Only

Increase [-, 21, -, 35] (-, -, -, -) stitches evenly in the next round as follows:

Increase Round: Knit [-, 3, -, 2] (-, -, -, -), [M1, knit [-, 6, -, 4] (-, -, -, -)] [-, 20, -, 34] (-, -, -, -) times, M1, knit [-, 3, -, 2] (-, -, -, -).

All sizes resume.

Stitch count—[154, 147, 161, 175] (182, 189, 203, 210) stitches present.

COLORWORK YOKE SECTION

Note: Switch to larger needle for colorwork rounds if necessary to maintain gauge. Two versions of charts are given, a light Main Color chart and a dark Main Color chart. Use the color scheme that best matches your project.

With Main Color and Contrast Color, work Rounds 1–[40, 46, 46, 46] (46, 46, 46, 46) of colorwork Chart [A, B, B, B] (B, B, B, B). Pattern is worked [22, 21, 23, 25] (26, 27, 29, 30) times around yoke.

Stitch count—[352, 357, 391, 425] (442, 459, 493, 510) stitches.

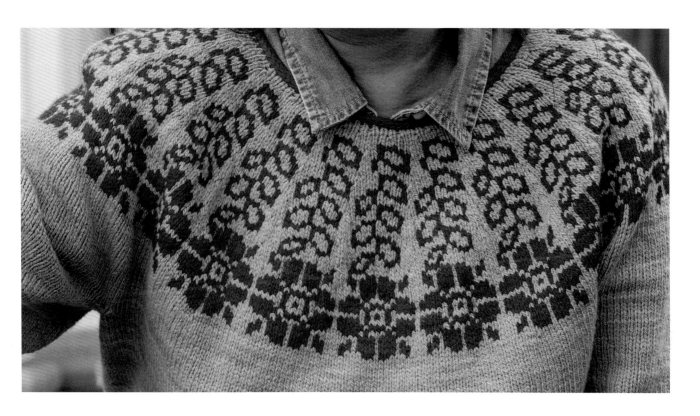

Chart B, Dark Main Color

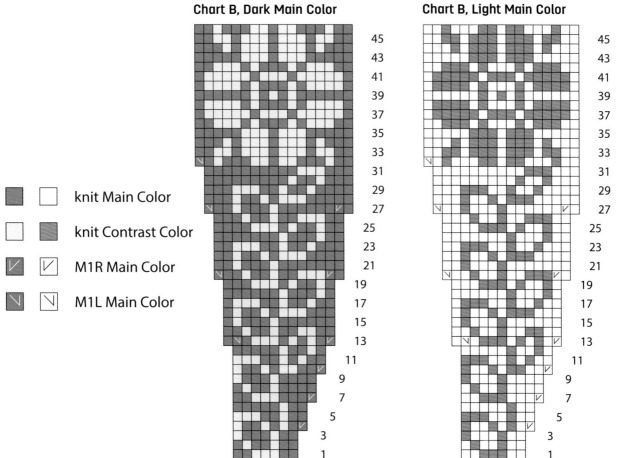

45
43
41
39
37
35
33
31
29
27
25
23
21
19
17
15
13
11
9
7
5
3
1

Chart B, Light Main Color

45
43
41
39
37
35
33
31
29
27
25
23
21
19
17
15
13
11
9
7
5
3
1

▨	☐	knit Main Color
☐	▨	knit Contrast Color
◣	◺	M1R Main Color
◥	◿	M1L Main Color

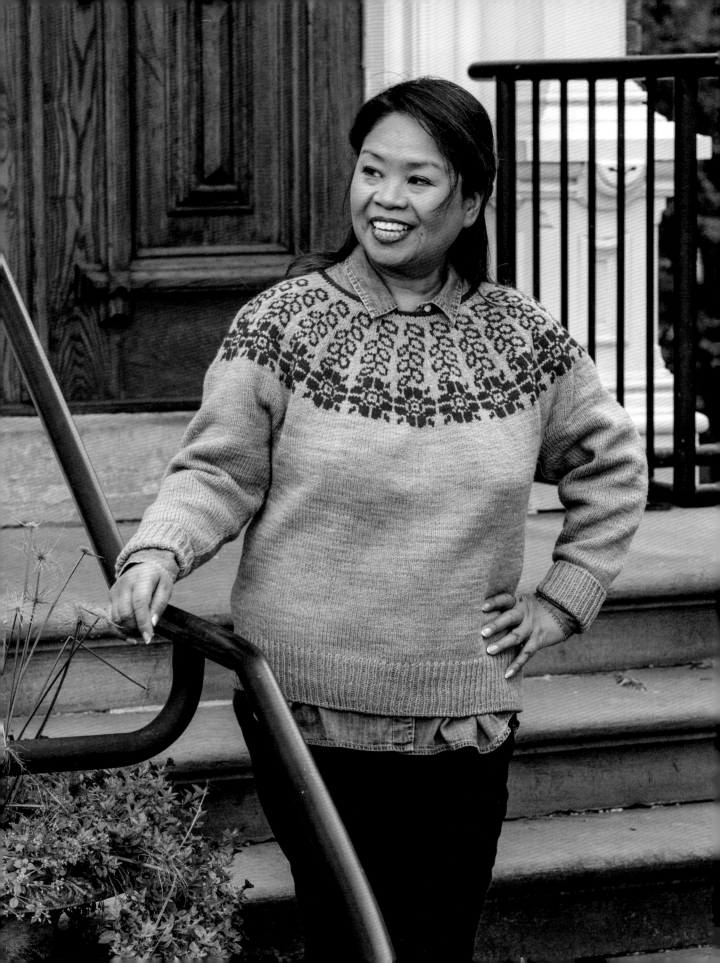

After completing all chart rounds, cut Contrast Color, leaving a 6" (15 cm) tail. Switch back to smaller, longer needle if necessary to maintain gauge.
Knit 2 rounds with Main Color.

Increase [19, 28, 22, 22] (24, 24, 18, 20) stitches evenly in next round as follows:

Increase Round: Knit [9, 6, 8, 9] (9, 9, 13, 12), [M1, knit [19, 12, 17, 19] (19, 19, 27, 26)] [5, 3, 2, 7] (5, 10, 5, 5) times, [M1, knit [18, 13, 18, 20] (18, 20, 28, 25)] [8, 21, 17, 7] (13, 3, 7, 9) times, [M1, knit [19, 12, 17, 19] (19, 19, 27, 26)] [5, 3, 2, 7] (5, 10, 5, 5) times, M1, knit [9, 6, 9, 10] (9, 10, 14, 13).

Sizes [F, G, H, I] (J, -, L, M) Only
Increase [19, 27, 21, 21] (24, -, 17, 20) stitches evenly in next round as follows:

Increase Round: Knit [9, 7, 9, 10] (9, -, 15, 13), [M1, knit [20, 14, 20, 22] (20, -, 30, 27)] [5, 10, 7, 3] (5, -, 8, 5) times, [M1, knit [19, 15, 19, 21] (19, -, 31, 26)] [8, 7, 6, 14] (13, -, 1, 9) time(s), [M1, knit [20, 14, 20, 22] (20, -, 30, 27)] [5, 9, 7, 3] (5, -, 7, 5) times, M1, knit [10, 7, 10, 11] (10, -, 15, 13).

Size [-, -, -, -] (-, K, -, -) Only
Increase Round: Knit 10, [M1, k21] twenty-two times, M1, k11.

Stitch count—[390, 412, 434, 468] (490, 506, 528, 550) stitches.

All sizes resume.
Knit [12, 8, 9, 11] (13, 15, 16, 18) more rounds or until Yoke depth measures about [9, 9¼, 9½, 9¾] (10, 10¼, 10½, 10¾)" ([23, 23.5, 24, 25] (25.5, 26, 26.5, 27.5) cm) along Center Front measured from CO, or to desired Yoke depth. Note: Center Front is directly opposite the BOR marker, which indicates the Center Back. It's important to measure here instead of at the BOR marker to avoid counting the short-row shaping depth that increases the depth at the Back Neck.

Fit Tip
For a perfect fit, try on before working the plain Stockinette section to determine how many more rounds to work. The Yoke should end just below your underarm to get the look shown. After working a few inches of the Body, try on again to be sure the underarm placement is comfortable and achieves your desired look. For a more accurate result, steam block your work-in-progress before trying on or checking gauge.

DIVIDE FOR BODY & SLEEVES
Dividing Round: Knit [58, 62, 66, 69] (73, 76, 81, 85) stitches for right half of Back (as worn).

Place next [80, 83, 86, 96] (99, 101, 103, 106) stitches on waste yarn for Right Sleeve.

CO [17, 17, 18, 19] (19, 21, 21, 21) stitches using backward loop method for Underarm (see **Techniques Glossary**).

Knit [115, 123, 131, 138] (146, 152, 161, 169) stitches for Front.

Place next [80, 83, 86, 96] (99, 101, 103, 106) stitches on waste yarn for Left Sleeve.

CO [17, 17, 18, 19] (19, 21, 21, 21) stitches using backward loop method for Underarm.

Knit [57, 61, 65, 69] (73, 76, 80, 84) stitches for Left Back.

Stitch count—[264, 280, 298, 314] (330, 346, 364, 380) stitches present for Body.

BODY
Work in Stockinette stitch (knit every round) until Body measures 11" (28 cm) from underarm, or 77 rounds at pattern gauge.

Hem

Ribbing Round: (K1, p1) to end.
Repeat ribbing round until Ribbing measures 3"
(7.5 cm), or 24 rounds at pattern gauge.

Bind off stitches using Tubular Bind-off method (see
Techniques Glossary).

SLEEVES (MAKE 2)

Place live Sleeve stitches on smaller needle for small-
circumference knitting. Join Main Color yarn and knit
to end. Pick up and knit [9, 9, 10, 10] (10, 11, 11, 11)
underarm stitches (one extra between sleeve stitches
and cast-on underarm stitches to prevent a hole from
forming, and one in each cast-on stitch), place marker
for beginning of round, pick up and knit [10, 10, 10,
11] (11, 12, 12, 12) underarm stitches (one in each cast-
on stitch, and one extra between sleeve stitches and
cast-on underarm stitches), knit to end of round.

Stitch count—[99, 102, 106, 117] (120, 124, 126, 129)
stitches.

In the next round, decrease away the extra stitches
that were picked up between sleeve stitches and cast-
on underarm stitches as follows:
Next Round (decrease): Knit [9, 9, 9, 10] (10, 11, 11,
11) stitches, k2tog, knit to [10, 10, 11, 11] (11, 12, 12,
12) stitches before marker, k2tog, knit to end.

Stitch count—[97, 100, 104, 115] (118, 122, 124, 127)
stitches remain.

Knit 16 rounds.

Decrease on next round and every 4th round [19, 17,
16, 11] (10, 9, 8, 8) times, then every 2nd round [4, 8,
10, 20] (22, 24, 26, 26) times as follows:
Decrease Round: Knit 1, ssk, knit to last 2 stitches,
k2tog—2 stitches decreased.

Stitch count—[49, 48, 50, 51] (52, 54, 54, 57) stitches
remain.

Knit 2 more rounds, or until Sleeve measures 15"
(38 cm) from Underarm.

Decrease [1, 0, 0, 1] (0, 0, 0, 1) stitch(es) in the next
round as follows:
Note: If the number for your size is 0, omit the
decrease round.
Decrease Round: Knit 1, ssk, knit to end.

Stitch count—[48, 48, 50, 50] (52, 54, 54, 56) stitches
remain.

CUFF

Work 1×1 ribbing for Cuff as follows:
Ribbing Round: (K1, p1) to end.
Repeat ribbing round 23 more times or until cuff
measures 3" (7.5 cm).

Work Tubular Bind-off as for Body.

I-CORD COLLAR

With smaller 16" (40 cm) needle and Contrast Color,
pick up and knit [100, 104, 104, 104] (104, 104, 110,
110) stitches around Neckline, beginning at Center
Back where cast-on tail is. Note: That's one picked-up
stitch for every cast-on stitch.

Bind off all stitches using I-cord Bind-off method (see
Techniques Glossary).

FINISHING

Weave in ends on WS using duplicate stitch.

Wet block

Hand wash sweater in room temperature water and
gentle soap or wool wash. Rinse by swishing gently
in clean water, then squeeze out excess moisture in
a towel. Lay flat to dry. After the sweater is dry, use
a steamer to steam out creases along the sides of
Sleeves and Body.

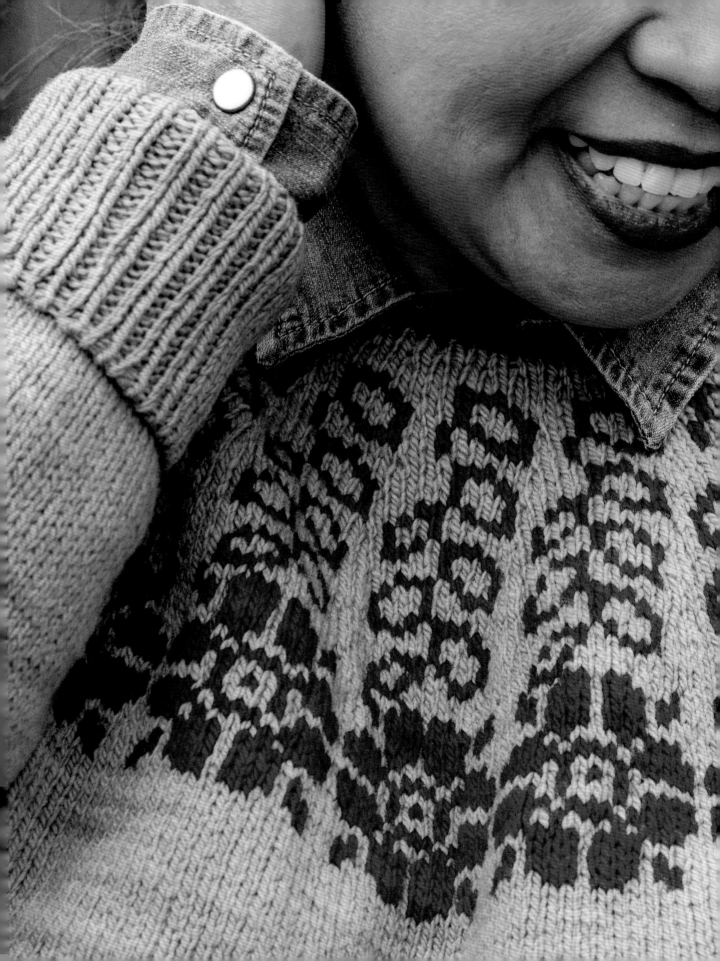

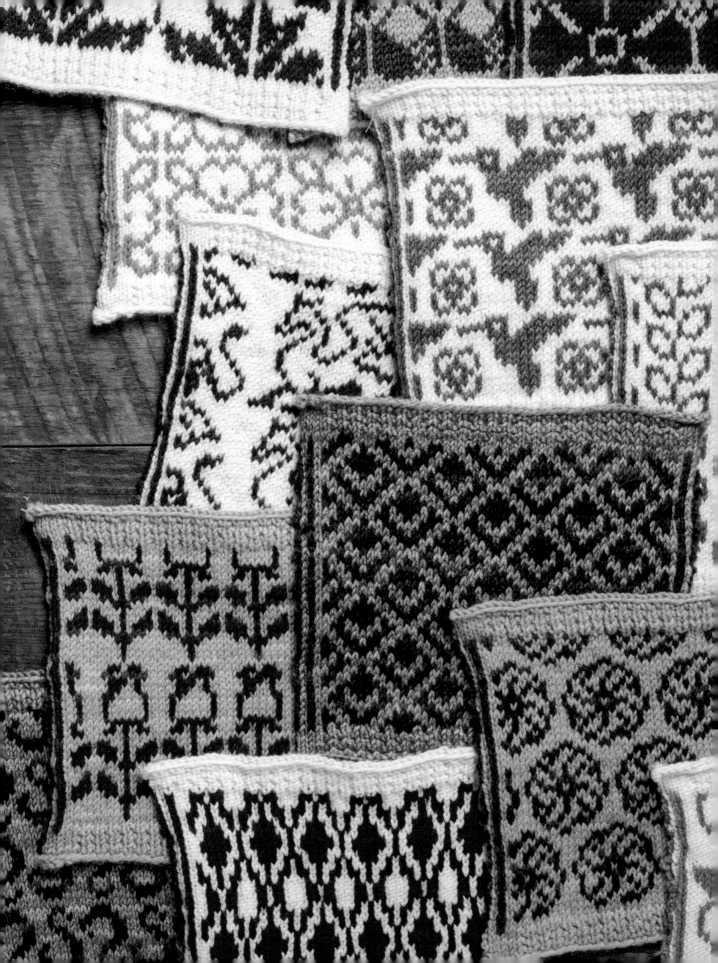

EXTRAS

ABBREVIATIONS

BO bind off

BOR beginning of round/row

CC contrast color

cir circular

cm centimeter(s)

CO cast on

g gram(s)

k knit

k2tog knit 2 stitches together (decrease)

kwise knitwise; as if to knit

m marker(s), meter(s)

MC main color

mm millimeter(s)

M1L make one with left slant (increase) (see **Techniques Glossary**)

M1R make one with right slant (increase) (see **Techniques Glossary**)

oz ounce

p purl

p2tog purl 2 stitches together (decrease)

patt(s) pattern(s)

pm place marker

pwise purlwise; as if to purl

rem remain(s); remaining

rep(s) repeat(s)

rm remove marker

rnd(s) round(s)

RS right side

sk2p slip 1 stitch knitwise, knit 2 stitches together, pass slipped stitch over (decrease)

sl slip (purlwise with yarn in back, uness instructed otherwise)

ssk slip 2 stitches knitwise, then knit slipped stitches together through back loops (decrease)

ssp slip 2 stitches knitwise, then return slipped stitches to left needle and purl 2 together through back loops (decrease)

st(s) stitch(es)

St st Stockinette stitch

tbl through back loop

w&t wrap and turn

WS wrong side

yd yard(s)

***** repeat starting point

() alternate measurements and/or instructions

[] work instructions as a group a specified number of times

TECHNIQUES GLOSSARY

COLORWORK TECHNIQUES

Color Dominance

When stranding two colors, one of them will physically fall below the other one as you work. The color below ends up with more yarn than the one that's stranded above, making the stitches in that color larger and causing them to visually pop more than the stitches made with the color that's stranded above.
The color that strands below is called dominant because it stands out more in the finished fabric. In order to get clean, clear colorwork, it's important to be consistent and always hold the same color dominant throughout your work, regardless of how you hold your yarn. It makes a subtle but definite difference in the look of the finished fabric.

Holding the Yarn

There are several ways to hold your yarn when knitting with two colors. I encourage you to try them all to find out which you prefer, but it's very important that no matter which you choose, you're consistent. Work in the same way for a whole project (including your swatch, which you definitely will be making and blocking and measuring, of course, because you always do, right?), and be sure to hold the colors in the same orientation throughout.

Holding One Color in Each Hand

My favorite method for working stranded colorwork is the two-fisted method. I hold a strand of yarn in each hand and then use picking to work the yarn in my left hand (also known as Continental knitting) and throwing to work the yarn in my right (English knitting). With this method, it's easy to get into a rhythm following the chart, I don't have to look at my knitting in order to know which color I'm using, and I can consistently keep one ball of yarn on my left and one on my right. Here's what that looks like:

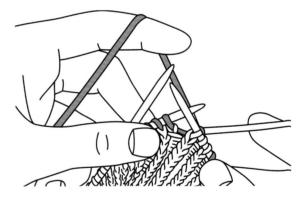

Hold the dominant color in your left hand and background color in your right.

Holding Both Colors in the Same Hand

Most knitters are primarily pickers or throwers, so using both hands at the same time can take practice. If you prefer, you can hold both colors in the same hand, but a major drawback of doing so is that if your pattern doesn't have about the same number of stitches in each color, or if you have long sections of one color, you'll have to drop your yarn to reestablish proper tension more frequently than you would if you worked the colors independently, one in each hand. That being said, you do you! Lots of knitters happily and successfully hold both strands in one hand, and here's how:

Left Hand (Continental/Picking)

When holding both strands in your left hand, you'll pick all stitches of both colors. Be careful to keep the dominant color to the left of the background color as you work. In this orientation, the background color will be the one closer to the tip of your index finger:

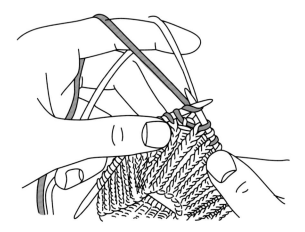

Hold both strands in your left hand, being sure that the dominant color is to the left of the background color.

Right Hand (English/Throwing)

You can also hold both strands in your right hand, throwing all the stitches of both colors, and being sure that the dominant color is held to the left of the background color.

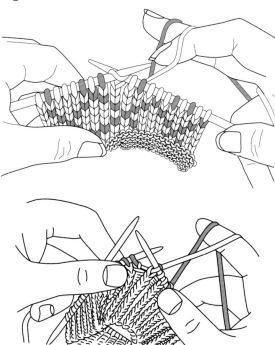

Hold both strands in your right hand, being sure that the dominant color is to the left of the background color. The dominant yarn can be tensioned over your middle finger and nondominant yarn tensioned over your index finger, or both strands can be tensioned over your index finger with the dominant yarn held closer to the tip of your finger.

CATCHING FLOATS

A float is the strand of yarn that's not currently being knit into stitches but is instead being carried along loosely behind the work. Floats more than 5 stitches long should be "caught" to avoid snags or tension issues. Here, I share how to catch floats based on how you hold the yarn.

Catching Floats While Holding Yarn in Two Hands

Dominant Wrap Light Color Dominant

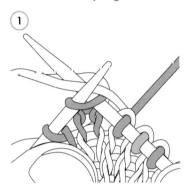

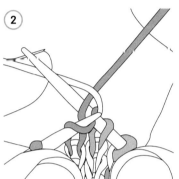

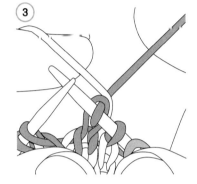

Insert right needle into next stitch and wrap dominant color over right needle from right to left (FIG. 1).

Then wrap the background color as if to knit, and unwrap the dominant color (FIG. 2).

Complete the stitch with background color (FIG. 3). Then knit the next stitch as usual in the background color. This catches the dominant color behind the background color.

Background Wrap Light Color Dominant

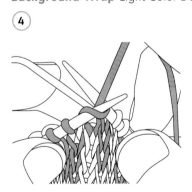

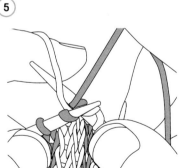

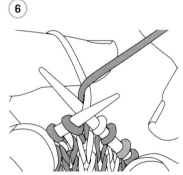

Insert right needle into stitch and wrap background color as if to knit, but don't complete the stitch (FIG. 4).

Wrap dominant color as if to knit (FIG. 5).

Unwrap background color and complete the stitch with dominant color (FIG. 6). Then knit the next stitch as usual in the dominant color. This catches the background color behind the dominant color.

Catching Floats While Holding Yarn in Left Hand

Dominant Wrap Light Color Dominant

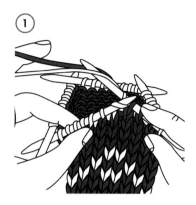

Insert right needle into next stitch and slide needle underneath the dominant color (FIG. 1).

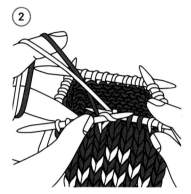

Knit the background color (FIG. 2). Then knit the next stitch as usual in the background color. This catches the dominant color behind the background color.

Background Wrap Light Color Dominant

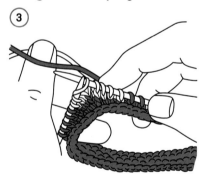

Insert right needle into stitch and use your left thumb to push the dominant color behind the background color from below (FIG. 3).

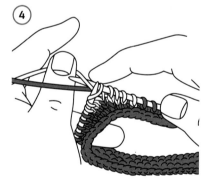

Going over the top of both strands, grab the dominant color from your thumb and knit it, keeping the background color out of the way with your thumb (FIG. 4).

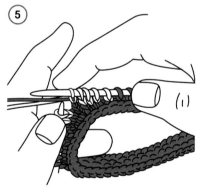

Once the stitch is complete, move your thumb out of the way and knit the next dominant color as usual (FIG. 5).

Catching Floats While Holding Yarn in Right Hand

Dominant Wrap Dark Color Dominant

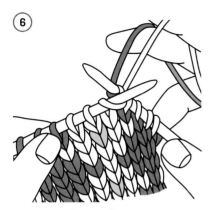

6

Insert right needle into next stitch and wrap the dominant yarn the opposite of the way you'd usually wrap for a knit stitch (FIG. 6).

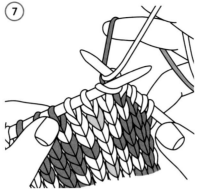

7

Wrap the background color as for a normal knit stitch (FIG. 7).

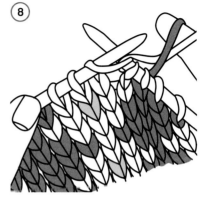

8

Unwrap the dominant color and complete the stitch with the background color (FIG. 8). Knit the next stitch as usual in the background color. This catches the dominant color behind the background color.

Background Wrap Dark Color Dominant

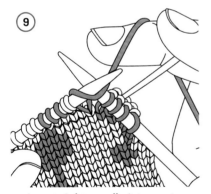

9

Insert right needle into next stitch (FIG. 9).

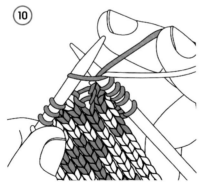

10

Wrap both yarns around as if to knit (FIG. 10).

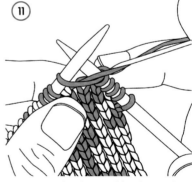

11

Unwrap background color and complete the stitch with dominant color. Knit the next stitch as usual in the dominant color. This catches the background color behind the dominant color (FIG. 11).

BIND-OFF METHODS
I-Cord Bind-off

Cable cast on 3 stitches (FIG. 1).

Step 1: Knit 2 stitches.

Step 2: Insert needle into next two stitches through the back loops and draw yarn through, knitting the two together (FIG. 2). There are three stitches on the right hand needle.

Step 3: Slip three stitches from right hand needle back to left hand needle (FIG. 3).

Repeat Steps 1–3 until all stitches have been worked. Bind off the last three stitches, cut the yarn, and draw the end through your last loop. Sew the bound-off edge of the I-cord to the cast-on edge.

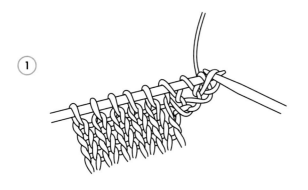

①

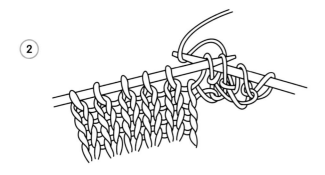

②

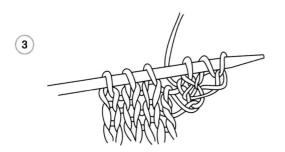

③

Tubular Bind-off

Round 1: *K1, slip 1 purlwise with yarn in front, repeat from * to end.

Round 2: *Slip 1 purlwise with yarn in back, p1, repeat from * to end.

All knit stitches will now be moved to one needle, while all purl stitches will be moved to another needle. The knits and purls will then be grafted together, creating the tubular bound-off edge. During this section, the stitches will be slipped, not worked, so leave the working yarn aside for now.

Step 1: Slip next stitch (a knit stitch) onto spare circular needle (the same size or smaller than your working needle) purlwise and hold to front.

Step 2: Slip next stitch (a purl stitch) onto the needle you've been using to work rib pattern purlwise and hold to back.

Repeat Steps 1–2 until all knit stitches are on one needle in front and all purl stitches are on another needle in back. Cut yarn, leaving a tail at least twice as long as the circumference of the edge you're binding off. Graft stitches from front needle to stitches from back needle until one stitch is on the front needle and one on the back needle. Slip the needles out from these stitches to complete the bind-off. Insert tapestry needle into first stitch of the round and draw through to close the round.

CAST-ON METHODS

Backward Loop Cast-on

*Loop working yarn as shown and place it on needle backward (with right leg of loop in back of needle). Repeat from * (FIG. 4).

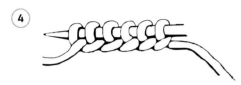

Crochet Provisional Cast-on

With smooth, contrasting waste yarn and crochet hook, make a loose chain of about four stitches more than you need to cast on. Cut yarn and pull tail through last chain to secure. With needle, working yarn, and beginning two stitches from last chain worked, pick up and knit one stitch through the back loop of each chain (FIG. 5) for desired number of stitches. Work the piece as desired, and when you're ready to use the cast-on stitches, pull out the crochet chain to expose the live stitches (FIG. 6). For a video tutorial of the Crochet Provisional Cast-on method using a crochet hook, visit www.andrearangel.com/tutorial-blog/crochet-provisional-cast-on.

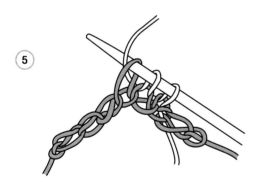

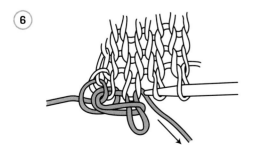

Long-tail Cast-on

Leaving a long tail (about 1–2" [2.5–5 cm] for each stitch to be cast on), make a slipknot and place on right needle. Place thumb and index finger of left hand between yarn ends so that working yarn is around index finger and tail end is around thumb. Secure ends with your other fingers and hold palm upwards, making a V of yarn (FIG. 7). Bring needle up through loop on thumb (FIG. 8), grab first strand around index finger with needle, and go back down through loop on thumb (FIG. 9). Drop loop off thumb and, placing thumb back in V configuration, tighten resulting stitch on needle (FIG. 10).

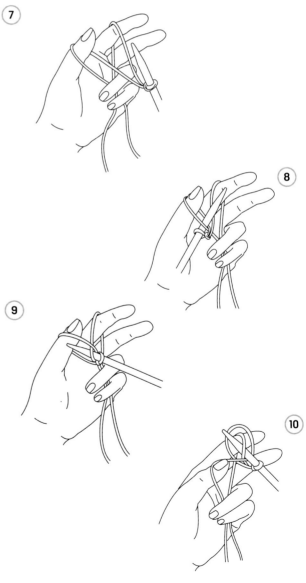

DECREASE STITCHES
K2tog (Knit 2 Together)

Insert the right needle from front to back into the next two stitches on the left needle (FIG. 1) and knit them together.

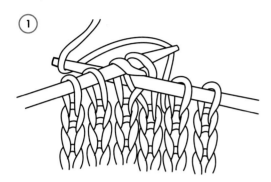

Sk2P — Left-leaning Double Decrease

Slip one stitch knitwise, knit the next two stitches together, then use the point of left needle to pass the slipped stitch over the knit stitch and off the right needle.

SSK (Slip, Slip, Knit)

Slip two stitches individually knitwise (FIG. 2), insert left needle tip into the front of these two slipped stitches, and use the right needle to knit them together through their back loops (FIG. 3).

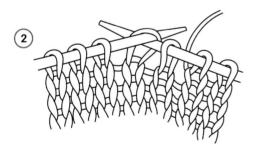

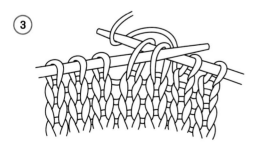

INCREASE STITCHES
MIL (Make 1 Left-leaning)

With left needle tip, lift the strand between the last knitted stitch and the first stitch on the left needle from front to back (FIG. 4), then knit the lifted loop through the back (FIG. 5).

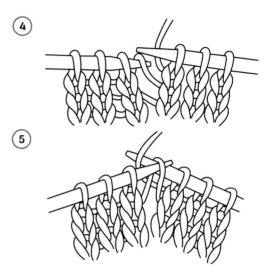

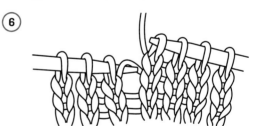

M1R (Make 1 Right-leaning)

With left needle tip, lift the strand between the needles from back to front (FIG. 6). Knit the lifted loop through the front (FIG. 7).

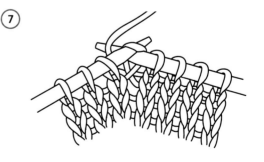

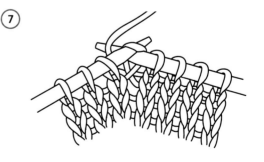

SHORT-ROWS
W&T Method (Wrap & Turn)
Knit Side

Work to turning point, slip next stitch purlwise (FIG. 8), bring the yarn to the front, slip the same stitch back to the left needle (FIG. 9), turn the work around, and bring the yarn to position for the next stitch—one stitch has been wrapped, and the yarn is correctly positioned to work the next stitch. When you come to a wrapped stitch on a subsequent row, hide the wrap by working it together with the wrapped stitch as follows: Insert right needle tip under the wrap (from the front if wrapped stitch is a knit stitch; from the back if wrapped stitch is a purl stitch; FIG. 10), then into the stitch on the needle, and work the stitch and its wrap together as a single stitch.

Purl Side

Work to turning point, slip next stitch purlwise to the right needle, bring the yarn to the back of the work (FIG. 11), return the slipped stitch to the left needle, bring the yarn to the front between the needles (FIG. 12), and turn the work so that the knit side is facing—one stitch has been wrapped, and the yarn is correctly positioned to knit the next stitch. To hide the wrap on a subsequent purl row, work to the wrapped stitch, use the tip of the right needle to pick up the wrap from the back, place it on the left needle (FIG. 13), then purl it together with the wrapped stitch.

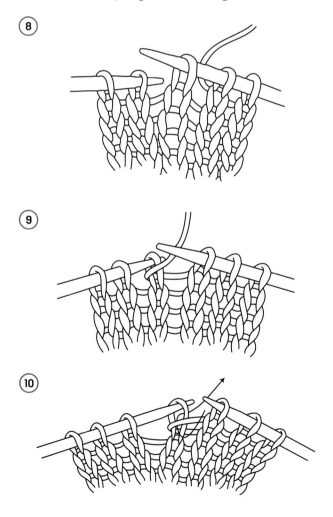

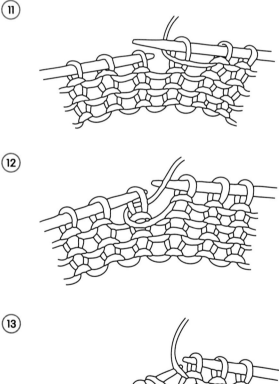

OTHER TECHNIQUES
Duplicate Stitch

Duplicate stitch is a method for embroidering on knitted fabric to create decorative embellishment or to hide yarn ends on the wrong side of your knitting. I use this method for weaving in my ends and love using it to add extra pops of color to my work.

Horizontal: Bring threaded needle out from back to front at the base of the V of the knitted stitch you want to cover. *Working right to left, pass needle in and out under the stitch in the row above it and back into the base of the same stitch. Bring needle back out at the base of the V of the next stitch to the left. Repeat from *.

Vertical: Beginning at lowest point, work as for horizontal duplicate stitch, ending by bringing the needle back out at the base of the stitch directly above the stitch just worked.

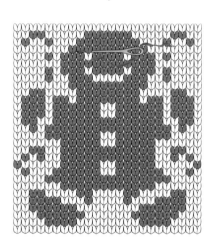
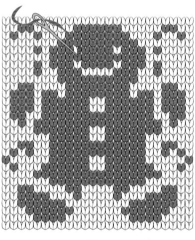
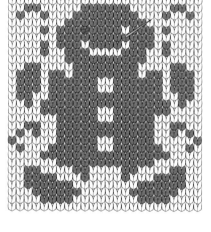

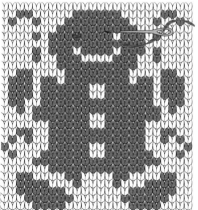
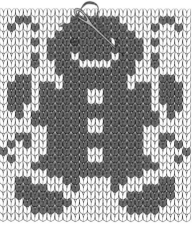

Use duplicate stitch to change the color of select stitches or to fix mistakes with ease.

CHAPTER 5

Indexes

STITCH COUNT INDEX

ROW COUNT INDEX

MOTIF A TO Z INDEX

(Note: The first number in parenthesis is the stitch repeat, and the second number is the row repeat. The last number is the page number.)

SUBJECT INDEX

ACKNOWLEDGMENTS

Big thanks to the folks who supported me throughout this book making process!

To my mom, for always asking how the book is coming along
and being so supportive of my work and all my endeavors.

To editor Kerry Bogert for her thoughtfulness and skill at making it all happen again for this book.

To technical editor Susan Moskwa for expertly honing my patterns.

To book designer Ashlee Wadeson for transforming ideas, pictures, and words into a real, beautiful thing.

To photographer Walter Colley for masterfully capturing my vision in images.

To the amazing yarn companies that create the materials for our craft. Your work inspires me!

Yarn support for this book was generously provided by:

Neighborhood Fiber Co.	*The Farmer's Daughter Fibers*	*Spincycle Yarns*
neighborhoodfiberco.com	*thefarmersdaughterfibers.com*	*spincycleyarns.com*
Baltimore, Maryland, USA	*Great Falls, Montana, USA*	*Bellingham, Washington, USA*

ABOUT THE AUTHOR

Andrea Rangel is an independent knitting pattern designer based in Victoria, BC, Canada. She's the author of *AlterKnit Stitch Dictionary* and *Rugged Knits* and has designed a multitude of knitting patterns. When she's not knitting, she's probably outside with her camera or inside with her sewing machine. You can find her online at AndreaRangel.com and on Instagram @AndreaRangelKnits.